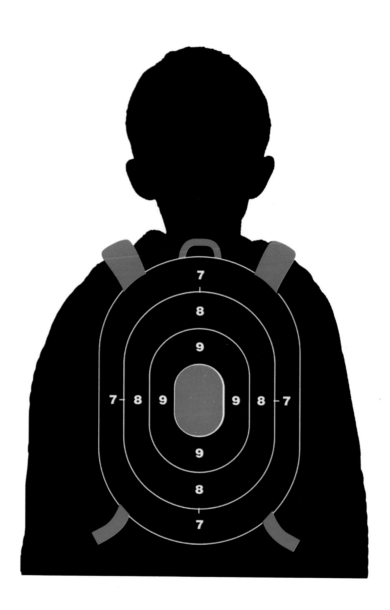

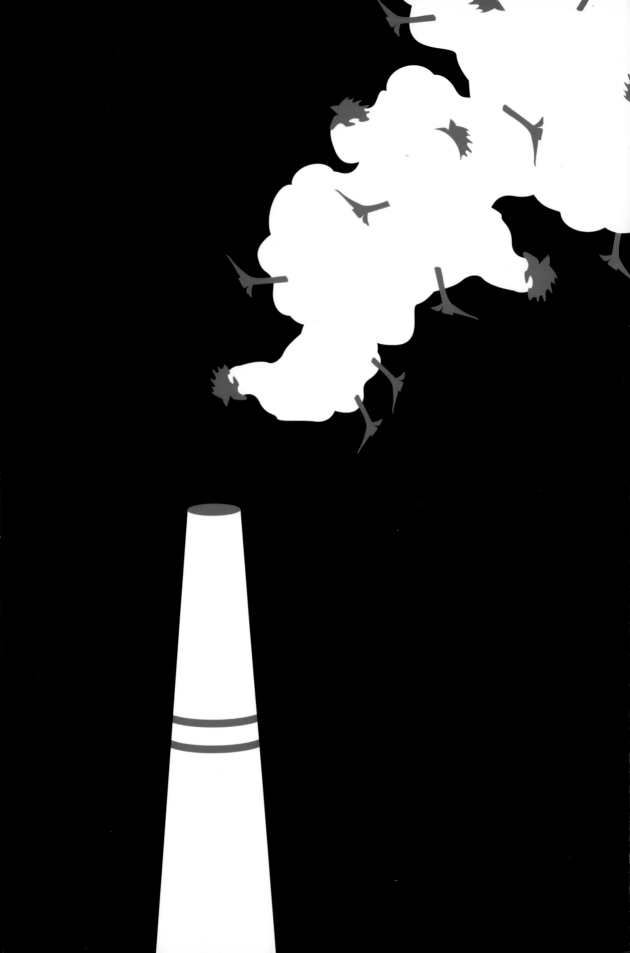

0 36000 29145 2

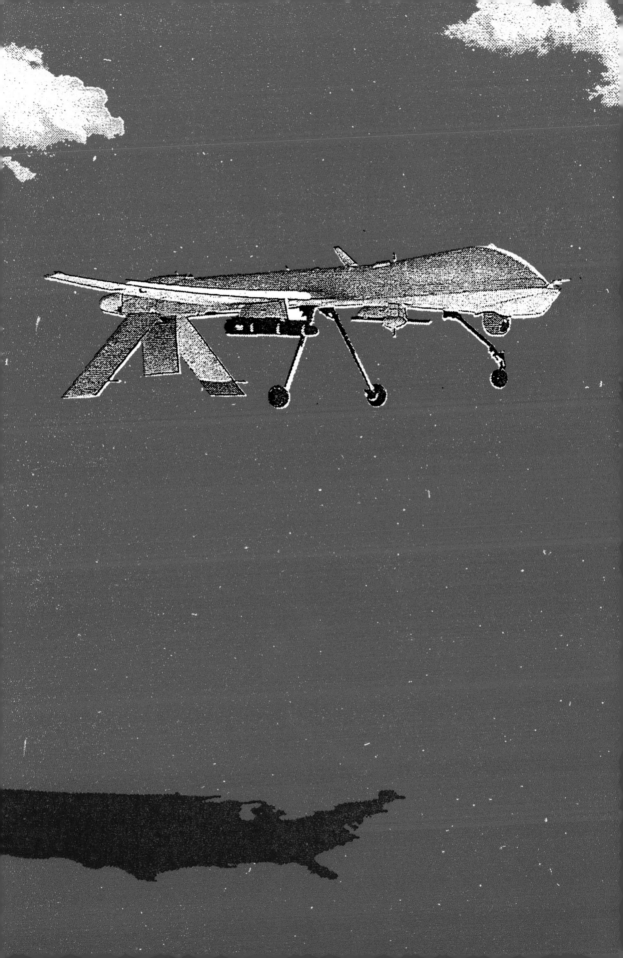

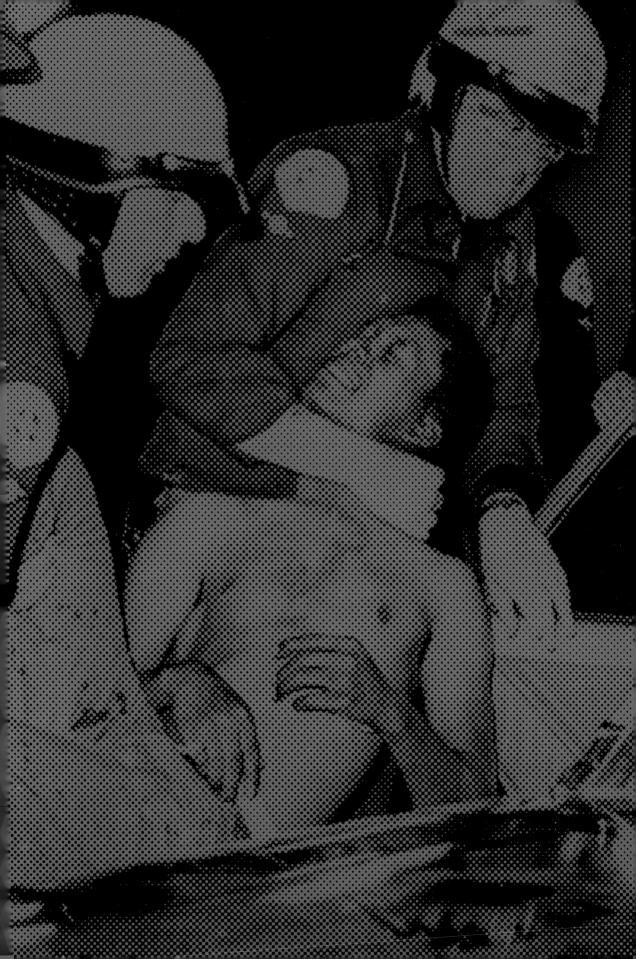

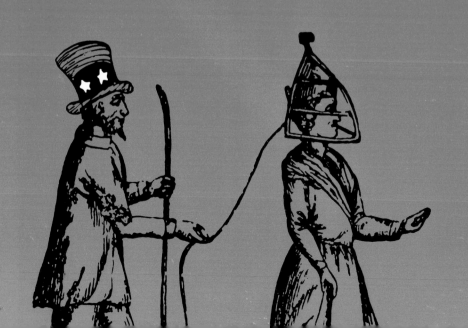

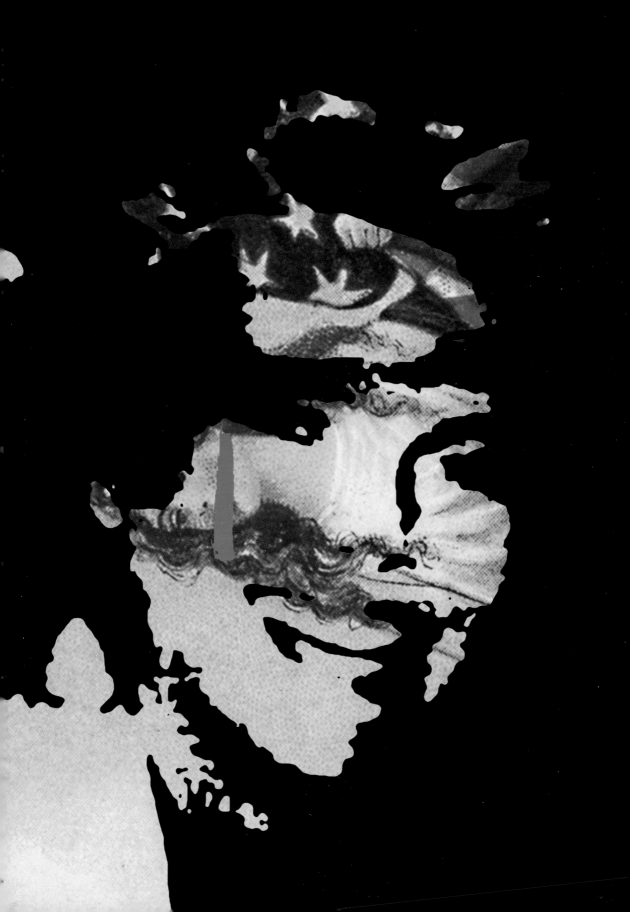

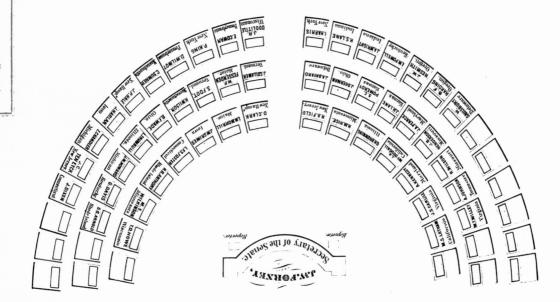

Store
Room

DON'T

SLEEP

DON'T SLEEP

———

THE URGENT MESSAGES
OF OLIVER MUNDAY

RIZZOLI NEW YORK

New York · Paris · London · Milan

for Robin

First published in the United States of America
by Rizzoli International Publications, Inc.
300 Park Avenue South, New York, NY 10010
www.rizzoliusa.com

For Rizzoli International Publications
Editor: Ian Luna
Editorial Coordination: Meaghan McGovern
Copy Editor: Mary Ellen Wilson
Proofreader: Angela Taormina
Production: Kaija Marko

Publisher: Charles Miers

Book Design: Oliver Munday

Printed in China

2018 2019 2020 2021 2022 / 10 9 8 7 6 5 4 3 2 1
Library of Congress Control Number: 2017959468
ISBN: 9780847861620

Contents

Hilton Als

I met the artist Oliver Munday through the great poet editor Deb Garrison on a fall day in New York. It was warm, and I was immediately struck by Munday's warmth. It was clear, almost at once, that, unlike a number of other contemporary artists, Munday was not crippled by his lack of humility. Indeed, so much of what he told me about his work and life that afternoon was an outgrowth of his modesty and desire to understand cultures and thus worlds not his own. That is what impels the true artist, or should: not the desire for fame and glory but a deeper understanding and feeling when it comes to the good and necessary questions, such as: What is the world like without me? And with me? And how can I see it, imagine it, for myself?

Munday works in a genre—for convenience sake let's call it graphic design—that relates more directly to the world than many other forms; he is in constant dialogue with the news of the world, which his eye and hand don't so much transmogrify as play off of, all in an effort to discuss the often undiscussable: race, certainly, and the body in particular. Munday makes writing visual; elements of his work look the way words feel as they come towards you; his shapes have the velocity of the best ideas, and certain truths. The moral heft in Munday's images doesn't mean it's weighted, but you can't deny the gravitas in his unpublished portraits of Martin Luther King Jr., and the pop phenomenon, Frank Ocean: these men are not unfamiliar to Munday, emotionally speaking. As he writes in his wonderful biographical essay he's a white male who grew up in a predominately black world; he was not unmoved by the inequality he saw there. Munday's art is not ideological but it does connect very vividly to the political.

I first saw his work, I think, in the *New York Times*, in the paper's opinion pages, and his graphics never overwhelmed the piece but enhanced it, made the truth of the author's words take on another life through figures or letters in space that

made the eye and then one's thinking open up, further, to the argument being presented: Munday collaborates with the text by finding an element in the writing that invites it. In a 2016 piece called "Secrets of the Book Designer: Sometimes I Don't Read the Whole Book," Munday describes how the real world—reading on the subway on his way to work—while trying to sip his iced coffee was as much a part of his reading life as his patience. Sometimes he finished a book, sometimes he didn't. But: "Often I read until I have found what I am looking for." What could that be? Words that don't impinge on his ability to dream in between the author's sentences, around their stated purpose, or intention.

When he was designing book covers full time for Knopf, Munday writes, he was partially expected to "read as a designer, which is to say economically and diligently." He's also describing here how the legendary film editors such as Thelma Schoonmaker look at a film: for ways to help the project become the project, only more so. To some extent Munday's job is to excavate what the writer and editor may not have known was buried in the text until someone like Munday makes it clear to their imagination.

Years ago, years and years ago, I worked as a graphic designer for a weekly newspaper. This was in the late nineteen-eighties, and I found design thrilling not because of what I could bring to it but, rather, what I saw artists such as Bruce Mau, and his work for Zone Books, could do: alchemize text and image in ways that changed my mind while helping to remake my mind. Munday's work brings me to that place again: the excitement of possibility, down to his choice of point size.

Graphic design—a term coined by the important type and book designer, William Addison Dwiggins in 1922—is as old as words and words are as old as people trying to communicate their ideas, the narratives that gripped the heart. What were those first stories? There were those cave drawings, of course, and during the mighty Tang Dynasty wood blocks were used to reproduce Buddhist texts and also images of textiles. Imagine: some of the earliest graphic work was about faith, and there was the designer shifting through articles of faith—words, images—the better to help frame those early poems of belief. In the fifteenth century, Gutenberg introduced movable type to the equation, and think about it, all of this energy devoted to reproducing reflection and getting it out there to as many people as possible is what artists like Munday live for, still. The excitement his work generates is as old and new as the ancients reacting to the news of the world through alchemy, the beauty that comes when images become words, and words, images. ∎

Oliver Munday

The illustration on my screen was humorous—nothing angry or explicitly political about it. I was finishing a small editorial piece for *The Washington Post,* and a final detail involved selecting a skin tone to represent the image's central figure. I clicked a pale swatch from the digital palette, always hovering in the top-right corner of my computer. The action was somewhat rote, on an otherwise routine afternoon, but I was suddenly provoked to ask a question of myself: *why?*

There I was, subtly advancing a narrative that had allowed me to believe certain facts about the world: that I was everywhere. A larger thought loomed: how many doctors, writers, scientists, or politicians had I chosen to render as white in the world of my imagery?

...

I grew up in Washington, D.C., on the white side of a stark racial divide. The '80s were over and Chocolate City, as it had once been known, was losing its flavor. Gentrification relocated families with rich history out into the peripheral counties of Maryland and Virginia. The legacy of Reagan's insidious policies continued to devastate certain communities, while ensuring that mostly white neighborhoods like mine remained unscathed. Its residents were lobbyists and judges; I had a lawyer for a stepfather with an office on K Street. My local elementary school, however, was a unique space that didn't reflect the segregation. It happened to be the most

diverse public school in the city, but to us, as kids, race was always secondary.

On paper, high school was no different. Resulting from a counter-intuitive zoning map, Woodrow Wilson Senior High was the public school for several districts on opposite ends of Washington, bringing a predominantly black student body to one of the whitest and most affluent neighborhoods in the city.

In the decades before I went, Wilson had been rife with conflict. Black kids jumped white kids in the hallways; white kids waited for retribution in alleys. A principal had been tossed out of a window. But beneath all the friction lay the origins of indelible cultural movements—Go-Go music and D.C. Hardcore had both come of age. My tenure during the early aughts wasn't as explosive along color lines, but the halls remained quietly segregated. Race felt significant, primary.

Socially, I was often the only white boy—a novelty—and I enjoyed being considered *down*. As I got older, the distinction proved complicated. An internal tension took hold. My family's tax bracket was emblematic of other disparities between my black friends and me. Our home and its abundance of unused rooms were hard to explain. I tried to distance myself from the money, but during the golden era of Jordans, allowance was tough to refuse.

The summer after sophomore year, a new Arts and Humanities initiative was tested in the district; a course list arrived in the mail. Among the standards was a curiously titled class: Intro to Computer Graphics. It seemed an interesting union of art and technology. My paternal grandparents had been artists, and I'd shown enough latent skill and interest over the years to warrant occasional encouragement—even in my sketchbooks, scrawled with graffiti. I signed up. The teacher was Mr. Bottorf, a parent filling the role as a labor of love. His day job was at ABC News, where he was responsible for the graphics on the nightly broadcast. Bottorf explained to our class of five that the typography and images floating next to the anchor's head constituted something called graphic design. It became clear that graphic design was everywhere, omnipresent to the point of invisibility, a thrilling revelation. *How weren't their more asses in the seats in this classroom?* I kept my enthusiasm on the low while anticipating the semester's projects. Tinkering away on the computer, I experienced a type of pure cognitive joy, unique within the walls of a classroom.

College was always on the horizon, hulking and inevitable, but art school had never occurred to me. The prospect of studying this practice that I loved didn't seem like work at all. The pursuit hinted, as Mr. Bottorf proved, at a livelihood. It reified a future.

My list of schools was short, whittled further by a promising relationship with a girl one grade below me. After a class

visit from an affable admissions officer, the Maryland Institute College of Art (MICA) jumped to the top. Its acronym didn't ring with the resonance of RISD or SVA, but MICA had history—the country's oldest art school. With a car and a girlfriend in D.C., forty-five minutes on I-95 was doable.

I knew Baltimore as the city where the Orioles played—D.C.'s adopted baseball team. On a tour of MICA, situated along the winding Mt. Royal Avenue, that began to change. The campus consisted of buildings that embodied an appealing ideology: an intersection of the classical and modern. The school's Main Building was a beautiful Renaissance revival, and the Brown Center's angled, glass façade gestured toward innovation.

Art school proved incredibly different from public school in D.C., and matriculating was jarring. It dawned on me, traipsing across the lawn of the freshman dorms, that I'd arrived in the land of the misanthropes. My Jordan IVs matched my polo, and yet there I was among the quiet goths, brooding punkers, and nervous nerds. It was the whitest place imaginable. Still, despite the hair dye and safety pins, it felt vital to be surrounded by aspiring artists who pursued their passions rigorously, with little regard for anything else.

After the third or fourth LISTSERV email bringing news of a student being accosted or worse, a new tension arose. This was an historic, white institution abutting North Avenue and

a predominantly underserved and black community—a near photo-negative of my experience at Wilson. What was I doing at MICA, anyway? I'd been lucky enough to stumble upon the design class in high school, and I'd worked diligently. But for certain friends, hard work and resilience weren't guarantees of success. I'd made it out, so to speak, where other kids I'd known were embroiled in conflict, violence. Some had been killed.

The first professor I met at MICA became the most influential. Bernard Canniffe, head of the undergraduate design department, was a scrappy Welshman who'd left Thatcher's Britain for America. He had a penchant for Doc Martens and Dickies, a designer who'd read his share of Marx. Bernard was an early leader in a new ideological movement in the field, extolling what he called Blue Collar Design Theory. Social responsibility within graphic design was a nascent idea, and Bernard was putting theory into practice, collaborating with community leaders, activists, and professors. Partnering with Johns Hopkins School of Public Health, Bernard conceived of a class—MICA/JHU Design Coalition—where designers were paired with organizations undertaking meaningful work in the city. I took it three times before graduating.

Bernard understood his role in the class-and-race dynamics playing out in Baltimore. He felt the tension, too, and

had ideas about channeling it. Design was not only a means of response, but engagement. I was incredulous the first time I heard him refer to it as storytelling.

Around this time, I became obsessed with constructivism. Most of my projects, regardless of subject matter, ended up looking like Bolshevik propaganda. The early 20th century work was subversive and exciting; a synthesis of aesthetic energy and political censure. Eventually, Bernard insisted that I stop copying the Russians, assuring me that while he certainly appreciated the avant-garde, there was more to draw from. He exposed me to the design of Emory Douglas and the Black Panthers, May '68, Cold War Cuba. Hearts and minds had been affected by these artists, it was clear, but the eye had been accounted for, too. Their images were profoundly striking. The work not only spoke, it made demands. Posters were large exclamation marks with dots implied underneath. Projects could be statements, rhetorical and powerful. Ideas were paramount.

Studying and emulating these bygone eras of design allowed me to find a voice. Images had a unique ability to distill and amplify ideas that were difficult to articulate. I was loud by proxy, without having to say a word. If anything, words were a hindrance. A project's need for explanation implied its failure.

· · ·

Two weeks after graduating I found work at a small ad agency in Canton, a post-industrial neighborhood a few miles from MICA. I struggled to assimilate into professional life, with its schedules and clients uninterested in my revolutionary ideas about design. Corporate brochures weren't built for subversion. I was certain this period was provisional, a stopgap of some sort before the *real* work began. Dues had to be paid, etc. But after just three months, I was out.

Shortly thereafter, a friend encouraged me to try my hand at editorial illustration. Designers like Paul Sahre, Luba Lukova, and James Victore were beginning to frequent the national editorial pages, space once reserved for a more traditional cut of illustrator. Op-ed and book review art functioned like scaled down posters, and there was dignity in being coupled with the prose. Inspired, I called Nicholas Blechman at *The New York Times* one afternoon and left a sanguine message with a brief introduction and my portfolio website. Later that evening, absolutely stunned, I had an assignment with a deadline in less than 24 hours. Everything about the pace, the brisk thinking required, ran counter to the sedentary nature of my former job. It was open-ended, interpretive, and substantive. I loved that the style was subordinate to the concept. As more of my assignments came out in print, I imagined the

images as markers of historical moments. Emblems.

I started to assemble a portfolio while securing sufficient odds-and-ends freelance work to survive. Fortuitously, I found an old storefront with available studio space a block from home. I split the rent with Mike Weikert, another important professor from my tenure at MICA who was equally leery of the corporate world. Bernard began dropping by during off-hours, checking in on the progress for clients we'd continued to work with from Hopkins and other community organizations. The three of us became a natural ensemble, and both Mike and Bernard indulged my idealism: there had to be a way to build a design studio that functioned like a non-profit, sustaining itself through various grants and arts funding. One that worked in the community, making an impact on the ground. We called it Piece. The name embodied our belief in a larger aim of social equity and justice, wherein design was constituent. We printed business cards with our mission writ large.

...

New York City looms over designers—the center of a field whose cultural radius is boundless. I'd been terrified of it forever, and in my trepidation the city became symbolic of a kind of shallowness: rat races, industry celebrity, and Eames-outfitted conference rooms. These were things that conflicted with what I'd cherished about a smaller, underdog city. I never expected to make it there, and especially in the circuitous way that I did—following a post-breakup detour through D.C.

To be back at home, living in one of the vacant bedrooms I had trouble explaining in my teenage years, was a bitter irony. After a fraught and overdue split, it became too painful to remain in Baltimore. D.C. was a transitional period, considering next steps while at the same time taking a breath. I discovered that post-college life for old friends strayed far from the career path I'd been on. The cusp of a recession meant that many had moved back in with parents. Jobs were elusive.

At first, I felt a separation anxiety from the studio, alienated from the world I had only started to discover. Piece was flourishing in my absence, but I soon found out that change was underway back in Baltimore, too. Bernard had accepted an offer to chair the department at MCAD in Minneapolis, and Mike was developing a new design program at MICA, one that would become the first graduate degree of its kind to focus on social justice. With all the opportunities being seized by colleagues and friends—many former classmates had moved to New York days after graduating—it felt time for a leap of my own.

To my surprise, there were ways in which New York felt familiar, natural even. Manhattan is where publishing lives—the writers, editors,

and publications—and in setting up a small studio there, I began meeting the art directors I'd known only through email, discovering a built-in network of sorts. They led me in new directions, suggesting companies and projects to pursue, broadening the breadth of my work. After years of admiring book jackets from shop windows and front-table displays, I was able to expand my portfolio to include them. The new medium complemented the ephemeral printed matter I was used to; books could reside on shelves for decades. I'd always considered them a kind of formal perfection, and the experience of designing jackets was familiar—conceptual and metaphoric as in editorial art—but there was space for a more interpretive aspect. A new way to synthesize emotion. I followed my passion from the fringes of publishing to its heart, working in the art departments of both Alfred A. Knopf and Farrar, Straus and Giroux, places that had seemed beyond reach.

Looking back on New York is difficult because I'm very much still here, but its effect is undeniable. The city is a principal organ in our national discourse, and it has felt integral to my work. The majority of what's to follow in these pages was made here.

Over the years, my vantage on design has varied; I made adjustments when I felt pigeonholed, and explored new territory when grounds weren't fertile. My process has remained relatively constant, but as I reflect, what's changed more than anything else is my understanding of graphic design itself. What it is and what it *does*.

The practice refuses a neat definition, but on certain days, it feels like a kind of bricolage, where I'm using the substance at hand to create something new. On others, designing means I'm in a Greek chorus, close enough to comment yet outside the main narrative. Often, the materials I use come complete with their own internal languages and histories that I arrange and order. Maybe it's something like storytelling after all.

Often in my case, the medium is the media: photographs, screen shots, and headlines—the index of public visuals that reflect the political moment. My process is contingent upon such imagery, but what alarms me is how instrumental such imagery has become in mediating our experience of the world. What does that mean for the desk-bound designer, tucked away and remote, making the ostensibly minor choice of a skin-tone swatch?

It's simple enough to recognize the big political statement in a work—the hero image or *cri de cœur*—but the granular details are equally significant. These choices are tiny signals, affecting the way the world is understood. With reality on its current course, the ante has been upped for those tasked with representing it, requiring further scrutiny and judiciousness. The output of imagery should be a reflection of what's around us, to be sure, even when

it means confronting truths that some might rather forget. But it also has the opportunity to be a projection; an aspiration to be reached.

I think of Baltimore frequently, feeling far from the fervor of those days. Coming to New York meant I'd abandoned something, not so much a place as an ideal. I used to qualify certain projects with a "social" or "political" distinction, a separate category where the good fight was fought. But in hindsight that framing was never entirely right. The individual machinations of the process—decisions on the page—aren't neutral. Size and shape are active, representing literal and figurative value. Compositional tension is an expression of belief, a point of view. Color is direct, but can subtly signify. The political isn't a space to work at all, it is the inherent mode of working itself. It has to be. ∎

1.
Criminal
Justice

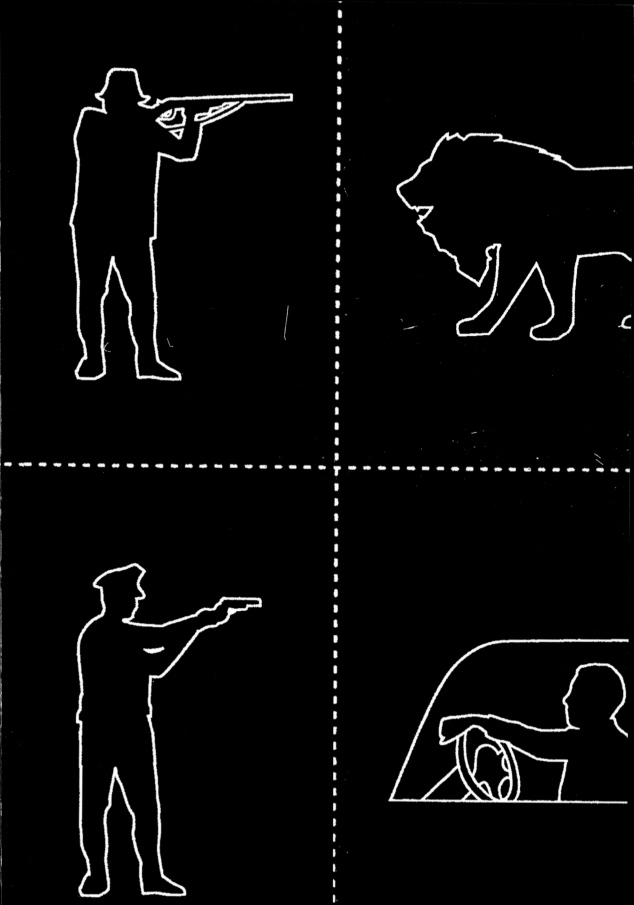

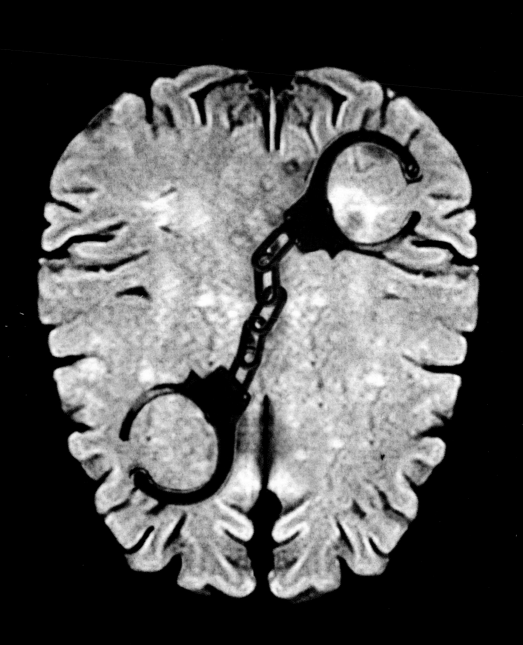

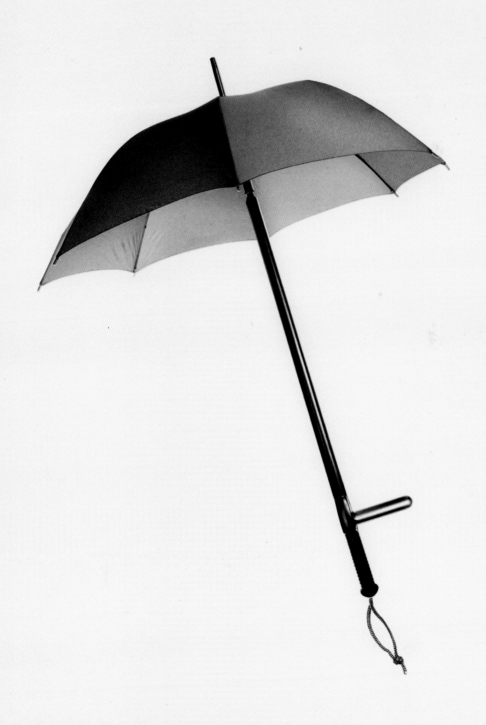

Policing the

Black Man

Edited and
with an
introduction
by Angela J.
Davis

(Previous spread)
(L) Anatomy of a Criminal
The Wall Street Journal, 2014

(R) Insuring Police
The Washington Post, 2016

(L) Book jacket
Pantheon, 2017

Police Portrayals
The Washington Post,
2016

43

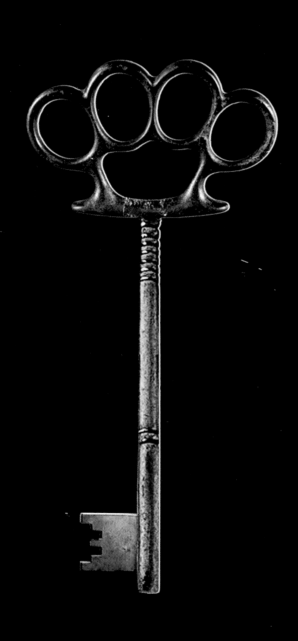

98435600079428658213521
87590965098730400000029
31582731592718759096509 8
730400000020935372398435
6000794128650000020000000
034123459127187590965 09
8730400110000209353723 98
41079428658213352187590 9
6509873040000002331173 59
27118759096509873040 0000
0209353723984135600079 42
81000 0

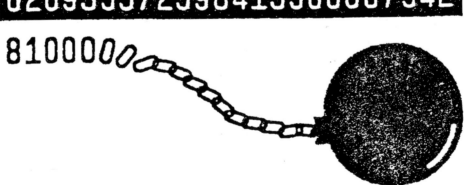

(Previous spread)
(L) Future of the Death Penalty
Harvard Law Bulletin, 2016

(R) The Rampant Abuses of Prison Guards
The New York Times, 2015

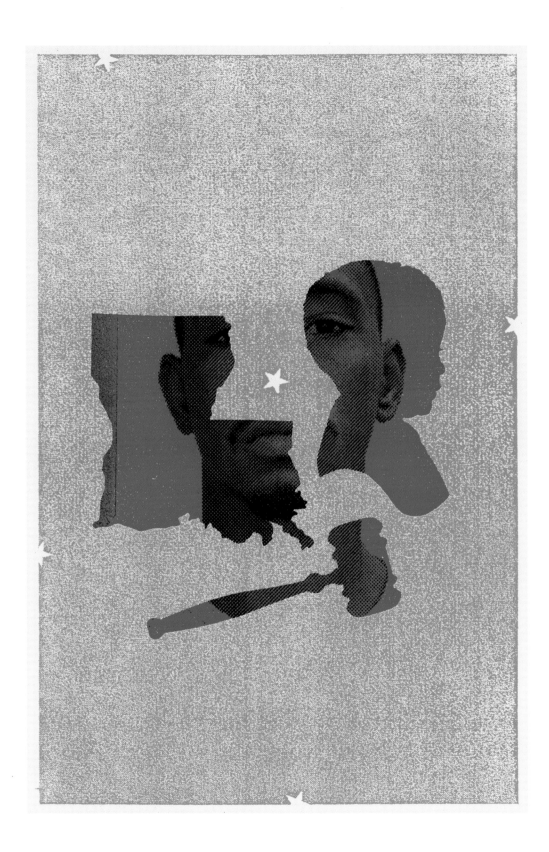

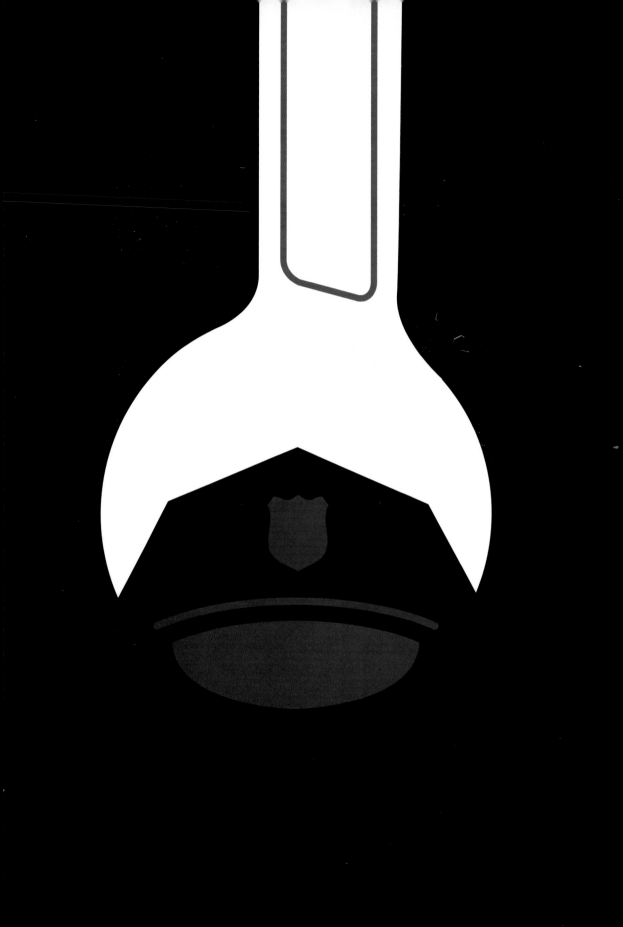

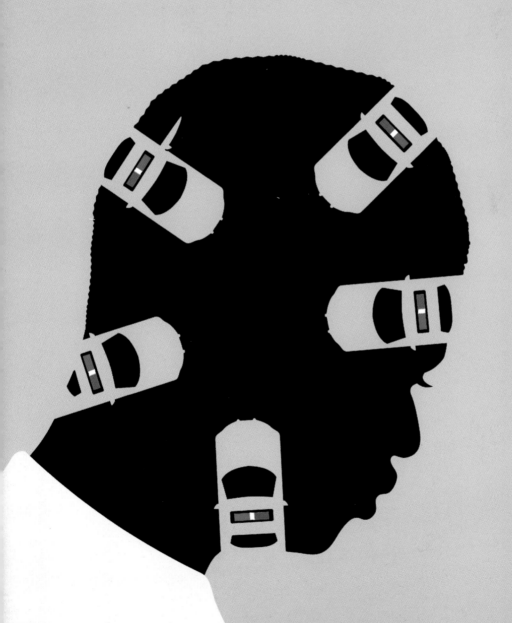

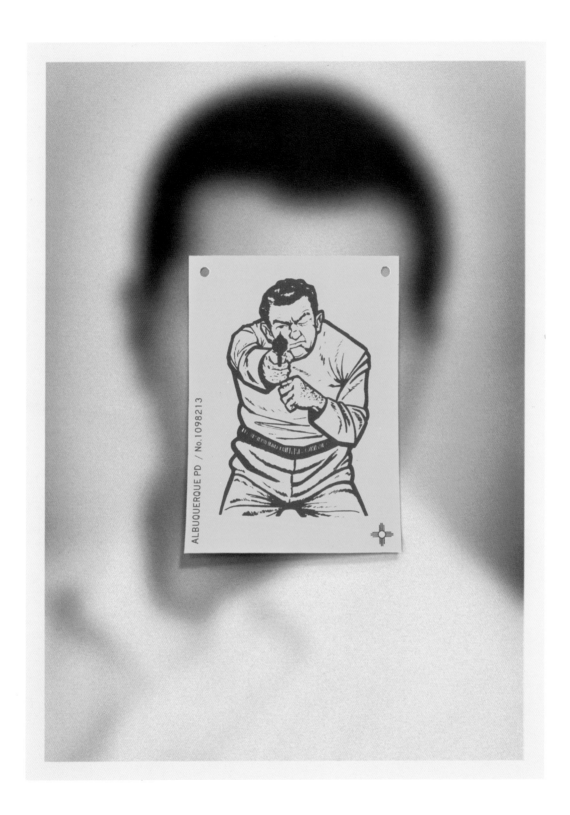

The image contains the text: "ALBUQUERQUE PD / No.1098213"

(Previous spread)
(L) Adjustment
Unpublished, 2015

(R) Policing Young Black Men
The New York Times, 2015

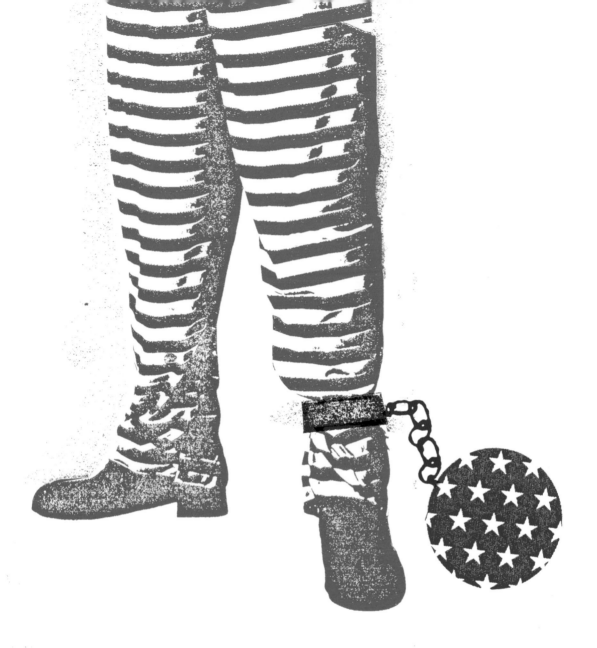

(L) Your Son Is Deceased
The New Yorker, 2015

American Mass Incarceration
TIME, 2012

**Criminal
Justice**

51

2.
Race

Book jacket
Pantheon, 2014

Negroland a memoir
Margo Jefferson

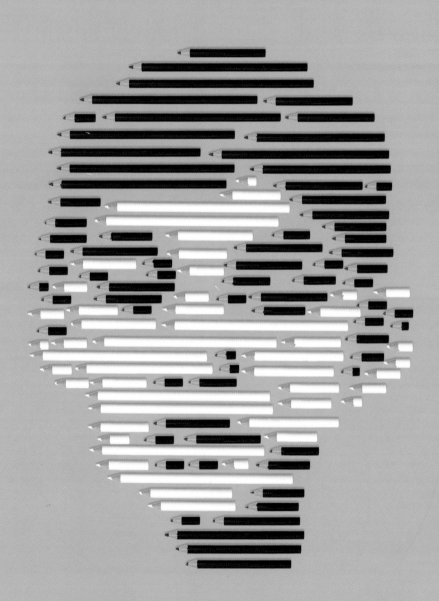

COMPITION
BOOK

100 sheets • 200 pages
9¾ x 7¼ in/24.7 x 18.4 cm

(Previous spread)
Segregation in NYC Schools
The Village Voice, 2016

(L) The Myths of
White Poverty
The New York Times, 2017

Book jacket
Knopf, 2016

Race

57

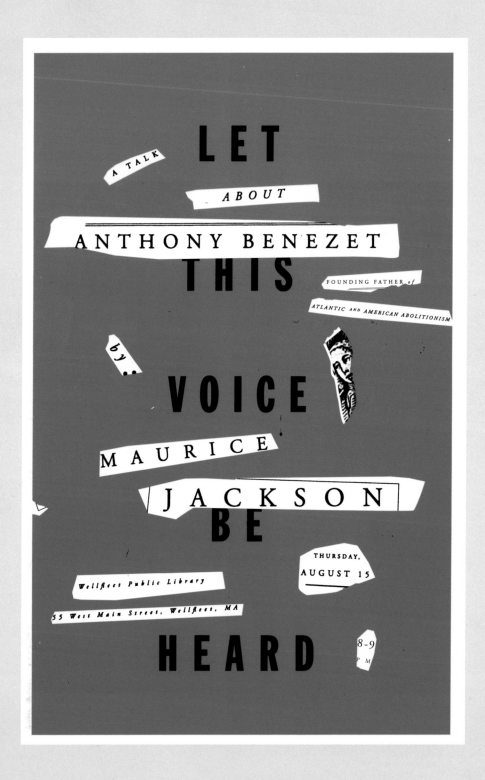

A TALK
LET
ABOUT
ANTHONY BENEZET
THIS
FOUNDING FATHER of
ATLANTIC and AMERICAN ABOLITIONISM
by
VOICE
MAURICE
JACKSON
BE
THURSDAY,
AUGUST 15
Wellfleet Public Library
55 West Main Street, Wellfleet, MA
HEARD
8-9 PM

Dothead

poems

Amit Majmudar

Book jacket (R) Voting Rights
Knopf, 2016 *The New Republic*, 2013

-100 0 100

YOUR FACE IN MINE

IN

MINE

JESS ROW

A NOVEL

WHO THE HELL IS ANGELA DAVIS?

Angela Davis will be coming to speak at MICA for "The State of Women's Rights" conference along with Helen Molesworth, curator of the Harvard Fogg museum, on Sept. 12th 2009.

MICA

Race

Poster, Maryland Institute
College of Art (MICA), 2009

(R) Poster
MICA, 2009

BLACK PANTHER

RANK + FILE

TOURÉ

WHO'S AFRAID

—— OF ——

POST-BLACKNESS?

What It Means to Be Black Now

COLSON WHITEHEAD

The

UNDERGROUND

A Novel

RAILROAD

3.
Democracy

Optics of Democracy
TIME, 2013

America, Lost
The New York Times, 2017

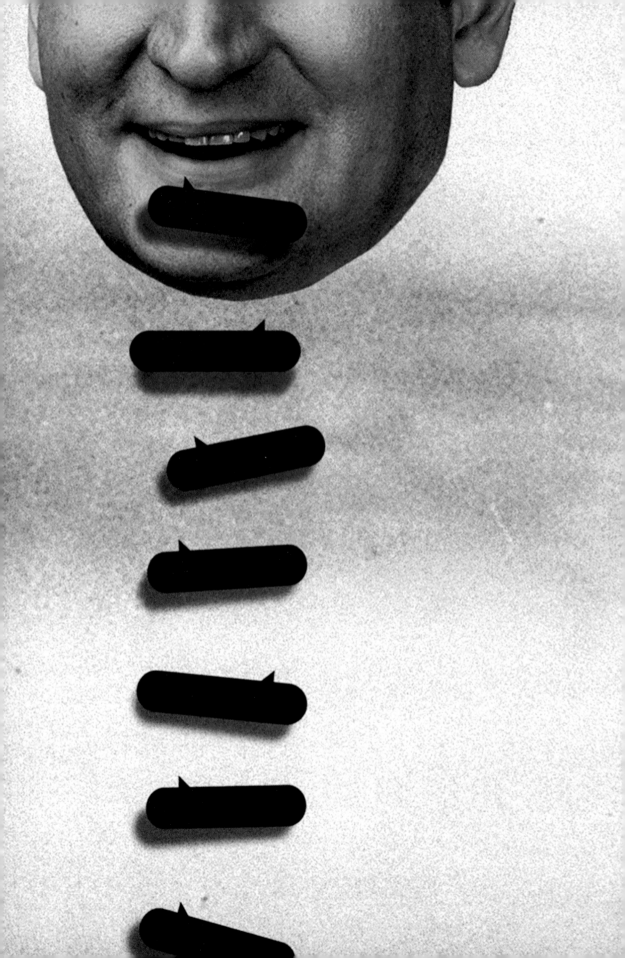

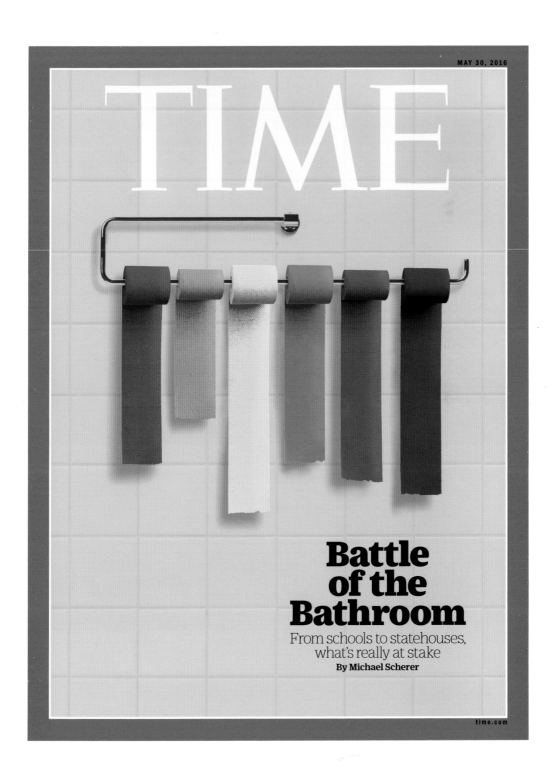

MAY 30, 2016

TIME

Battle of the Bathroom

From schools to statehouses,
what's really at stake

By Michael Scherer

time.com

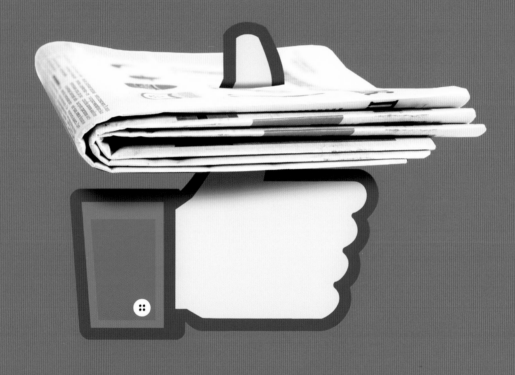

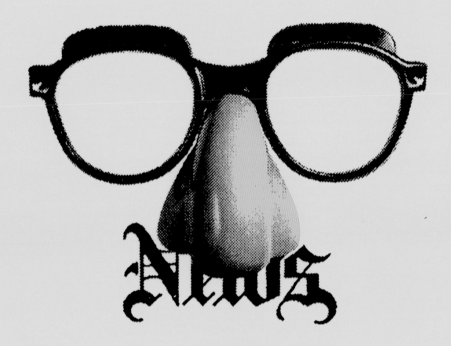

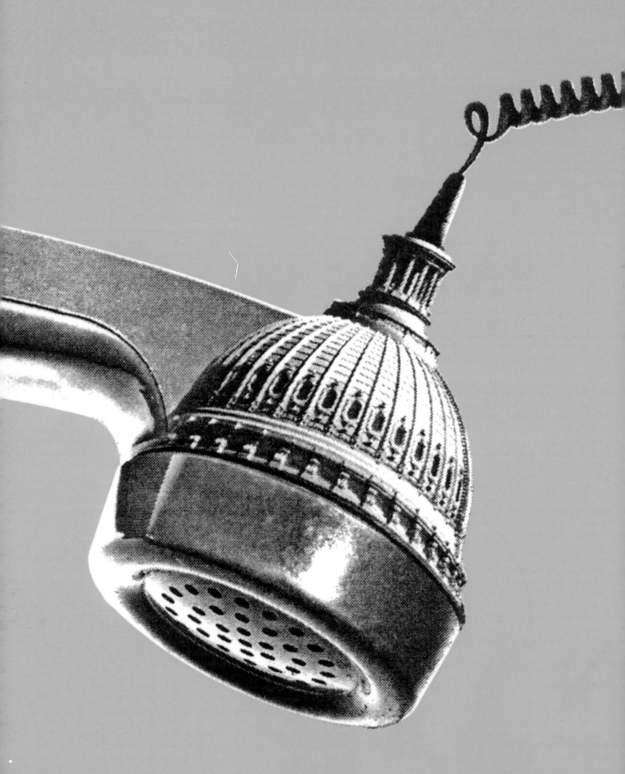

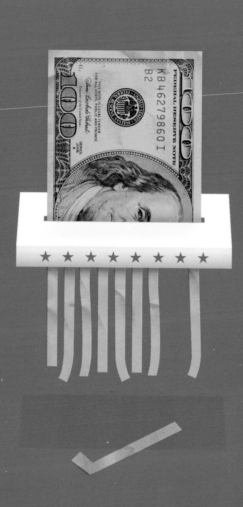

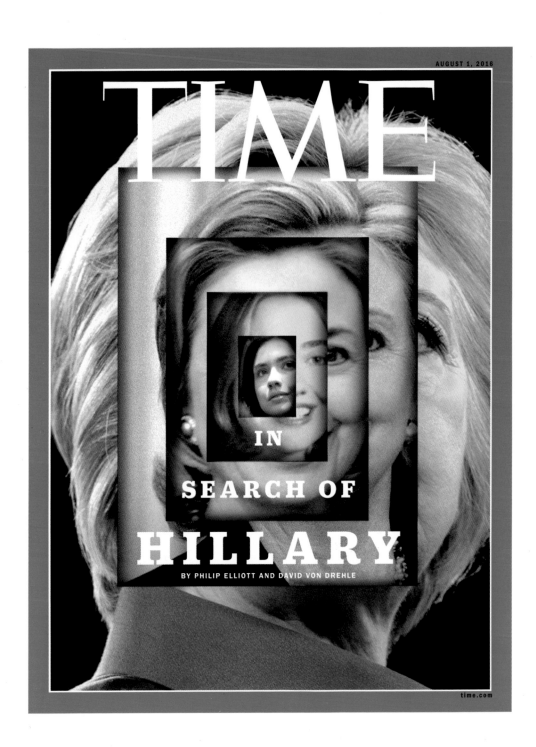

AUGUST 1, 2016

TIME

IN SEARCH OF HILLARY

BY PHILIP ELLIOTT AND DAVID VON DREHLE

time.com

(L) General in the Pentagon
The New York Times, 2017

(Top) NYC's Rotten Budget
The New York Times, 2015

Social Security's Future
The New York Times, 2009

Democracy

81

Democracy | Poster (R) Difficult Voting
The Foreign Policy Dunce, 2011 *The New York Times,* 2010

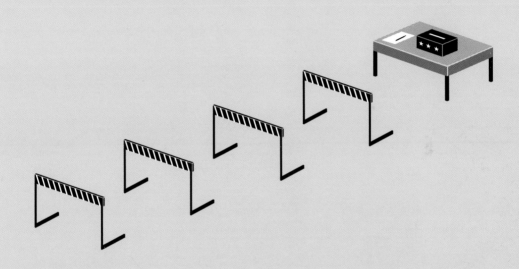

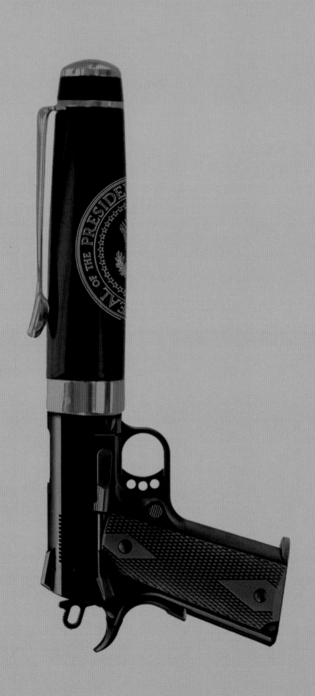

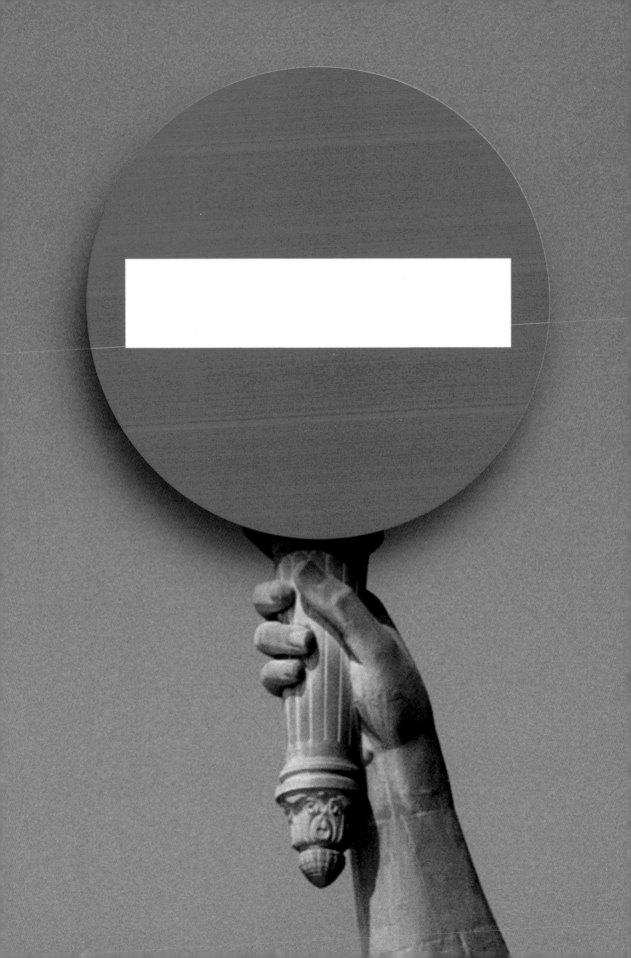

GO OD

DO

THE
GOOD
100

WHO IS PUSHING
THE WORLD
FORWARD IN 2013?

WWW.GOOD.IS/GOOD-100

ISSUE 028 $7.95 U.S. / $7.95 CDN
SPRING 2013 DISPLAY UNTIL JUNE 18, 2013

0 73361 08311 1

3 1>

(Previous spread)
(L) Obama's Action on Guns
The New York Times, 2016

(R) Immigration
Hypocrisy
The Washington Post, 2015

Cover
Good, 2013

(R) Silenced Victims
The Washington Post, 2015

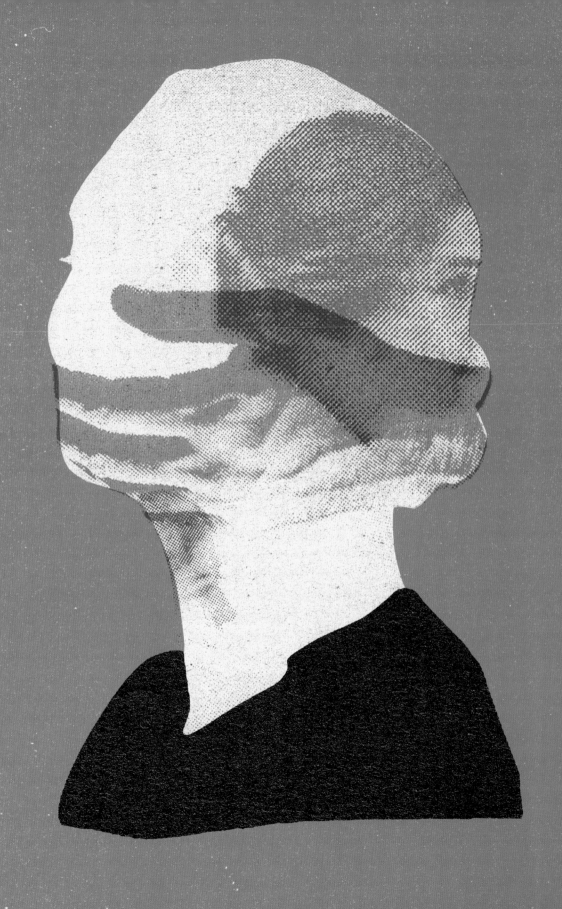

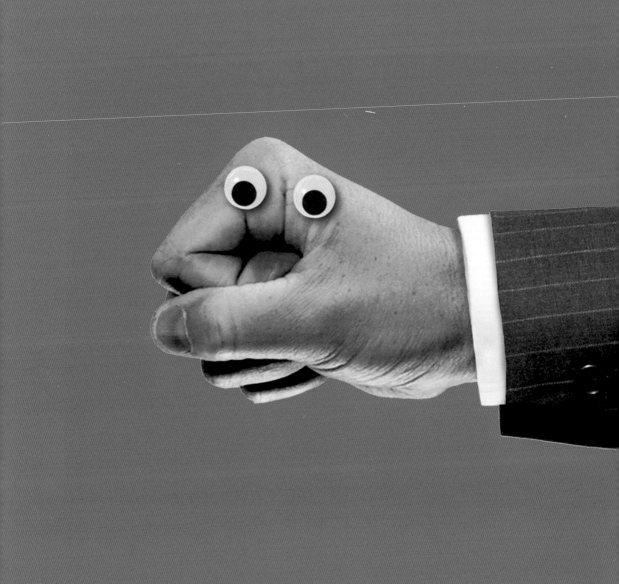

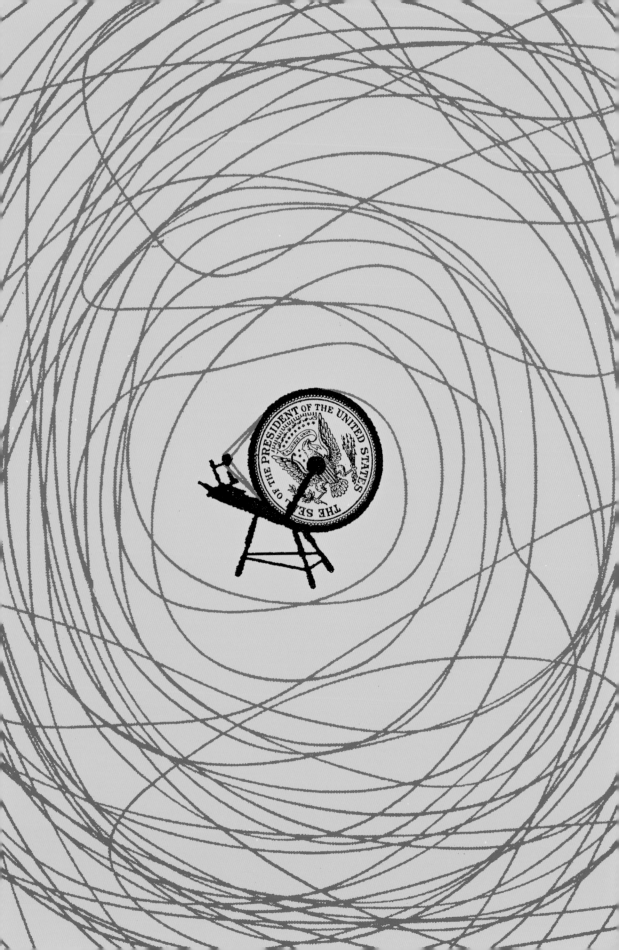

THE CORNEL WEST THEORY

P E R F O R M I N G L I V E

WHERE: _____ WHEN: _____

(Previous spread)
(L) Truth in the Age of Trump
The New York Times, 2016

(R) Presidential Body
Language
The New York Times, 2015

(L) Trumplestiltskin
The Washington Post, 2017

Poster
Cornell West
Theory, *2011*

91

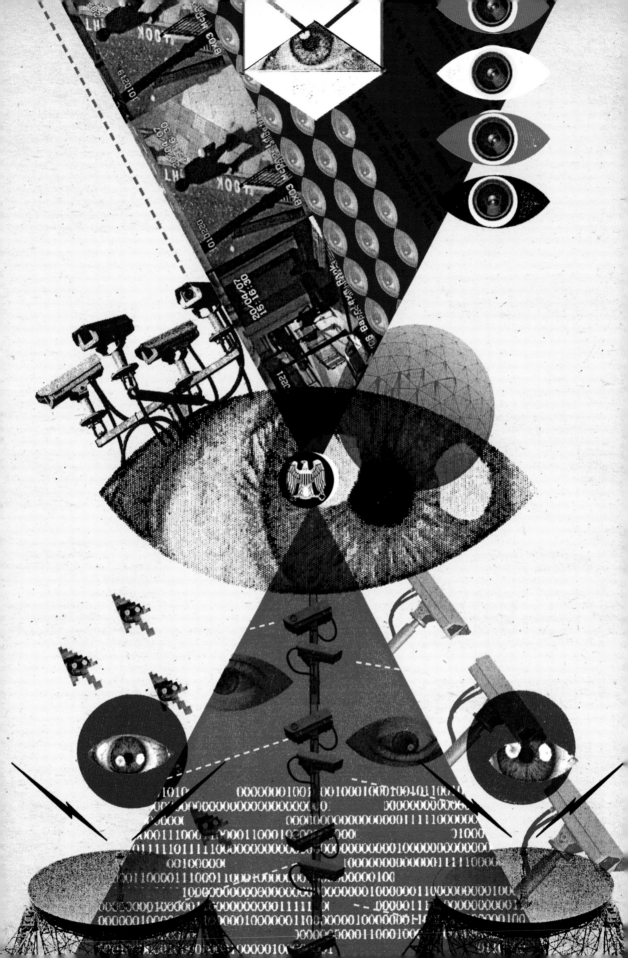

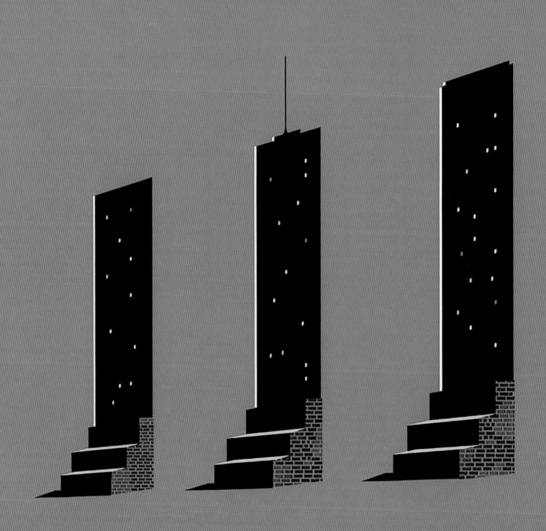

A Journal of Politics and Culture

NOV/DEC 2017 ISSUE 1

Robert Kagan *The Jungle Grows Back* Progress is not inevitable or irreversible. We must protect it. **David Grossman** *The Human Infinity* What does literature have to do with peace? **Kassem Eid** *Judgment Day: A Memoir of an Atrocity* A Syrian activist survives a chemical attack and takes up arms to defend his home. **Sean Wilentz** *Liberal and Progressive* Distinctions that must be made. **Anne Applebaum** *Old Bolsheviks, New Bolsheviks* A century later, the ghosts of October 1917 haunt Russia and the world. **Michael Gerson** *God and Man at Mar-a-Lago* Evangelicals and the president. **Timothy Snyder** *The Prophet of Putinism* The story of Ivan Ilyin, the unknown master of Russian fascism. **Jed Perl** *Art, Authority, and Freedom* From the medievals to Mondrian. **Adam Kirsch** *All Too Posthuman* Will technology transform humanity? Should we let it? **Jennifer Homans** on Balanchine and mystery. **Thomas Chatterton Williams** on the identity strategy. **Cass R. Sunstein** on the many adventures of American idealism. **Ruth Franklin** on the trouble with Karl Ove Knausgaard.

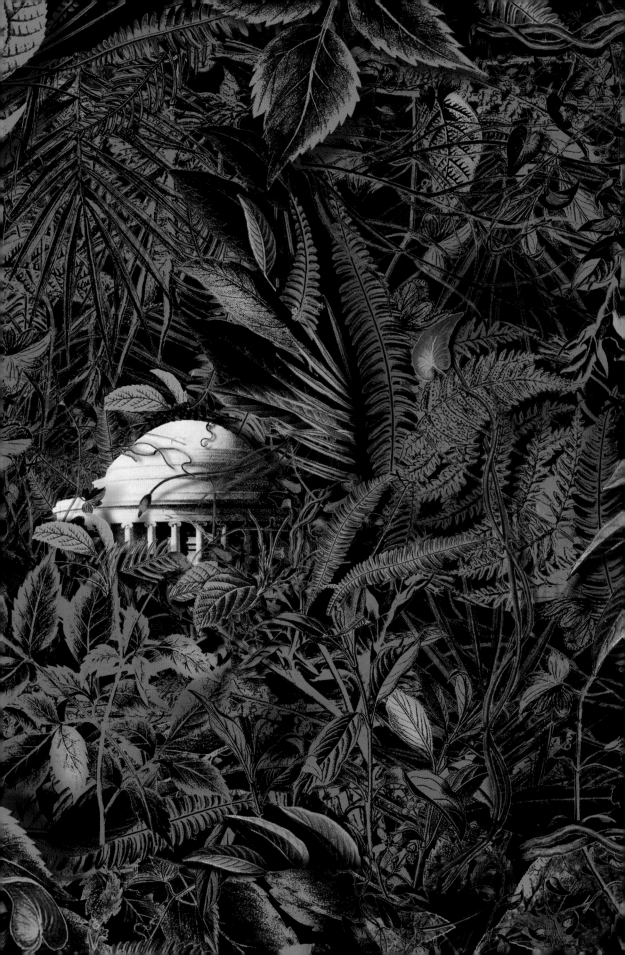

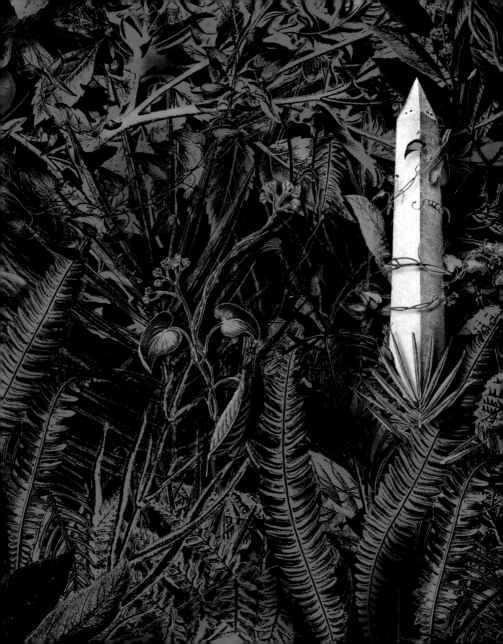

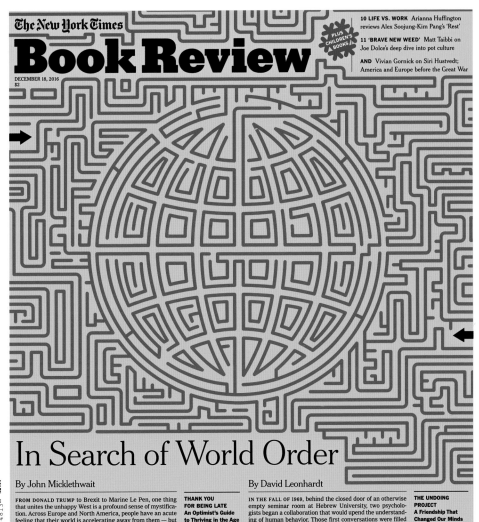
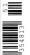

(Previous spread)
The Jungle Grows Back
Idea, 2017

(L) Poster
Voting Rights, 2017

Cover
*The New York Times Book
Review,* 2016

Democracy

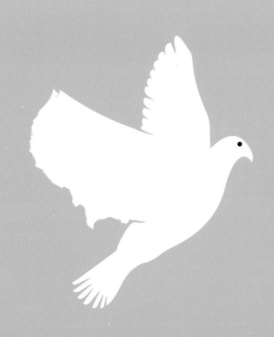

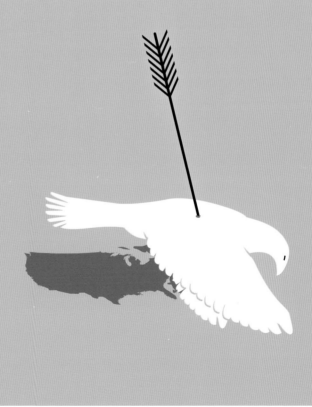

(L) Trump's Dubious
Dealings in Georgia
The New Yorker, 2017

Loving Liberals, Hating Liberals
The New York Times, 2012

Democracy

101

4.
Education

Admitting the Undocumented
The New Yorker, 2017

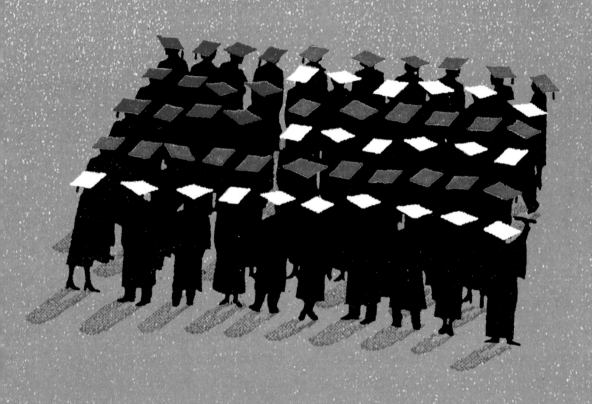

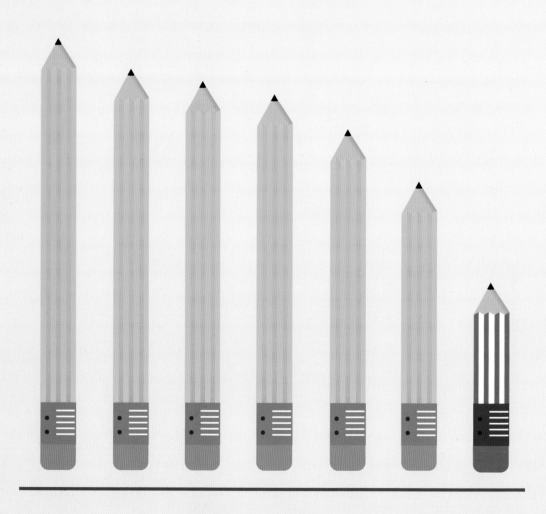

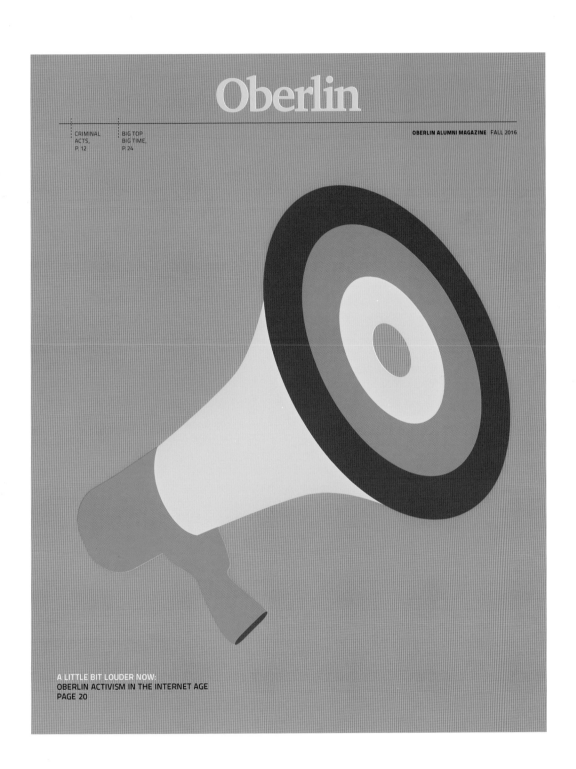

Oberlin

OBERLIN ALUMNI MAGAZINE FALL 2016

A LITTLE BIT LOUDER NOW:
OBERLIN ACTIVISM IN THE INTERNET AGE
PAGE 20

(L) America's
Remedial Education
TIME, 2011

Cover
Oberlin, 2016

Education

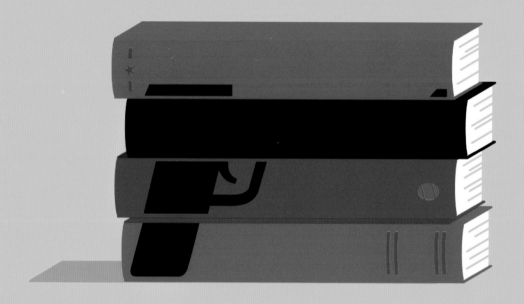

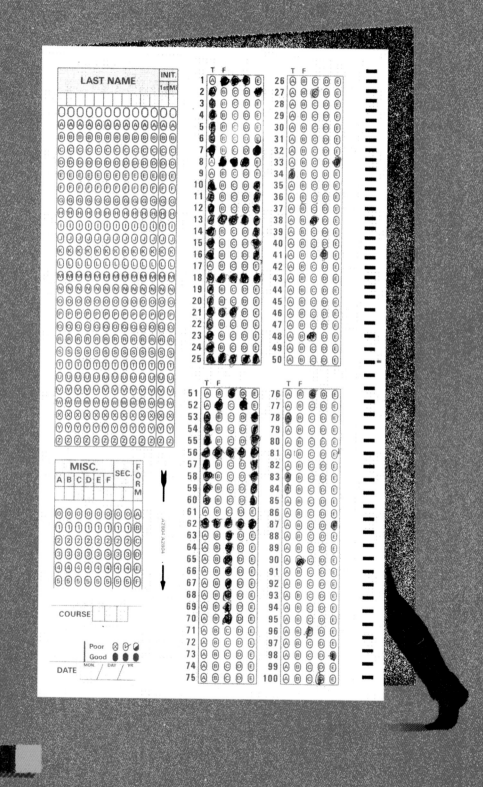

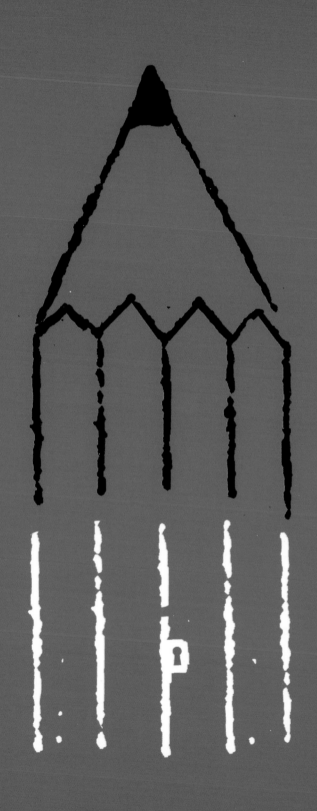

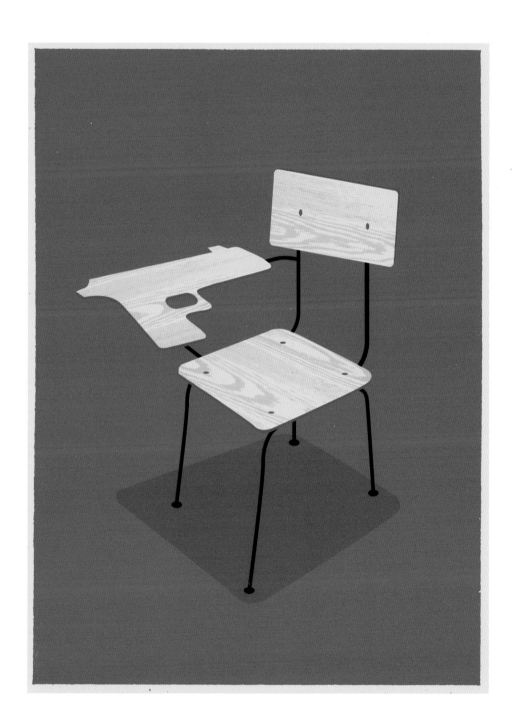

(Previous spread)
(L) Carrying at School
The New Yorker, 2016

(R) Ethics of Testing
The New Yorker, 2014

(L) Book cover
Free Minds, 2009

The Psychology of Violence
The New Yorker, 2017

826DC

The troubled start of 826Valencia turned out to be fortuitous. After finding a perfect rental space to house a tutoring center in San Francisco, the writer Dave Eggers and his partners discovered it was zoned strictly for retail. Rather than abandoning ship, they decided to use the front of the building to satisfy the restriction, while maintaining their educational intentions in the back. The result was The Pirate Supply Store, an imaginative shop selling products with a curious sense of humor that appealed to kids and parents alike.

The popularity of both shop and tutoring program became an effective model, and soon a panoply of equally inventive chapters opened across the country, and finally the organization's headquarters, 826 National. Having the opportunity to work with 826DC, my hometown chapter, was fulfilling on several fronts. It was the type of project I'd always dreamed of working on as a design student, with an open-ended, utopian brief. In the process, an incredible team of writers, artists, designers, and curators was assembled to implement 826DC's odd and apt theme to life: The Museum of Unnatural History. The project involved everything from the assembly of mini-museum displays, to the design of signage and tote bags, a singularly challenging experience that encouraged everyone to step outside of their comfort zones.

Working with the organization has also been a way to re-engage with the city where I grew up. An ongoing part of my role is designing the books produced through their Young Authors Book Project (YABP). Partnering with local schools—including on occasion my own Wilson high—826DC organizes writing projects with the aim of ending up in a physical book, an inimitable point of pride for aspiring authors of any age.

With volunteer waiting lists brimming, the educational reach of the local chapters is remarkable and always ascendant. The organization has reimagined and redefined the ways in which education can be effective, how it can be implemented. As is so often with creative pursuits, the story of 826 proves that a roadblock often leads to more interesting territory.

OOOOOOOOOOOO!

8·2·6·DC

CATCH IT *LIVE!* IN THE 202

WILD

Come AND See

FULL of INTRIGUE and MYSTERY

???????????????

N

AMAZING

WWW.826DC.ORG

WEIRD

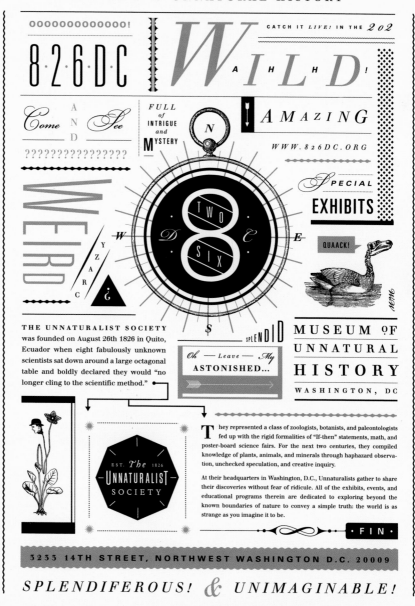

TWO 8 SIX

D C

W Y Z A R C ¿

SPECIAL EXHIBITS

QUAACK!

Oh — Leave — My ASTONISHED...

S spLENDID

MUSEUM OF UNNATURAL HISTORY

WASHINGTON, DC

THE UNNATURALIST SOCIETY was founded on August 26th 1826 in Quito, Ecuador when eight fabulously unknown scientists sat down around a large octagonal table and boldly declared they would "no longer cling to the scientific method."

EST. 1826 The UNNATURALIST SOCIETY

They represented a class of zoologists, botanists, and paleontologists fed up with the rigid formalities of "If-then" statements, math, and poster-board science fairs. For the next two centuries, they compiled knowledge of plants, animals, and minerals through haphazard observation, unchecked speculation, and creative inquiry.

At their headquarters in Washington, D.C., Unnaturalists gather to share their discoveries without fear of ridicule. All of the exhibits, events, and educational programs therein are dedicated to exploring beyond the known boundaries of nature to convey a simple truth: the world is as strange as you imagine it to be.

· FIN ·

3233 14TH STREET, NORTHWEST WASHINGTON D.C. 20009

SPLENDIFEROUS! & UNIMAGINABLE!

FORMA
DEHYDE

37% SOLUTION

The
UNNATURALIST
SOCIETY
EST. *The* 1826

Tradescent's Rarities

UNICORN
TEARS

PUTS THE *SPARKLE*
IN SUFFERING

SAFARI HAT AND SOUP BOWL

*You Never Know Where Adventure Will Take You,
But You'll Want Soup When You Get There.*

NATURAL
SELECTIONS

st Acting

-STINKT
PRAY

a THING OF THE PAST

FLUID OUNCES (636ML)

QUICK & EASY DIRECTIONS
MIX SOUP + 1 CAN SEA WATER

LIGHTNING: HEAT, UNCOVERED, IN EARLY SEAS FOR 2 TO 5 MILLENIA. LEAVES SIMPLE MOLECULES TO FORM LARGER, MORE COMPLEX ONES. CAREFUL, YOU'RE PLAYING GOD HERE, STIR.

HOT UNDERWATER SPRINGS: HEAT, STIRRING OCCASIONALLY.

CREAMIER SOUP: USE 1 CAN ORGANISMS.

Wallace's
CONDENSED

LATER
LIFE FORMS
LOVE IT
NOW WITH MORE O₂

PRIMORDIAL
SOUP

For four billion years, we've been making the tasty soup from a vyce emerged even tastier. We use only Earth-grown organic ooze and a special blend of prebiotic compounds. As always, this soup has:

• HUNDREDS OF AMINO ACIDS • NO MSG ADDED
 • NO CHOLESTEROL
• NO ARTIFICIAL LIFE • NO REGRETS

Nutrition Facts	Amount/serving	Amount/serving
Serv. size (1/2 cup) condensed soup	Total Fat 0g	Sodium 440 mg
Servings about 2.5	Sat. Fat 0g	Potassium 650 25g
	Trans Fat 0g	Total Carb. 20g
Calories 90	Polyunsat. Fat 0g	Fiber 1g
Fat Cal. 0	Monounsat. Fat 0g	Sugars 12g
	Cholesterol 0mg	Protein 2g

Vitamin A 0% • Vitamin C 10% • Iron 4%

PROMPTLY REFRIGERATE ANY UNUSED SOUP IN UNNATURALIST BRAND FUTURE MOLD™ CONTAINERS.

INGREDIENTS: PREBIOTIC PUREE (WATER, SIMPLE ORGANIC COMPOUNDS, AMINO ACIDS, PURINES), PYRIMIDINES, FATTY ACIDS, SIMPLE SUGARS), TOMATOES, SEA SALT

MUSEUM ºF UNNATURAL HISTORY

RESPLENDANT
Plumage
HIGH POTENCY *for* MATE ATTRACTION
EVOLUTIONARY SUPPLEMENT

200 TABLETS

NATURAL
SELECTIONS

FROM THE MAKERS OF PetrifiedWood™

EXISTENTIALLY DISTAUGHT

WOOD

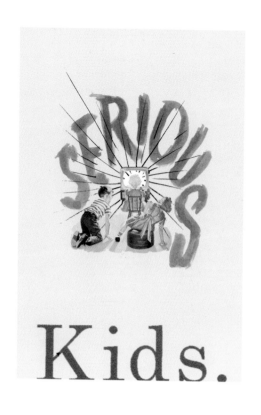

A COLLECTION
of STORIES BY
STUDENTS FROM
— THE —
SEED SCHOOL of
WASHINGTON D.C.

Introduction by
DARIN STRAUSS
Foreword by
W. RALPH EUBANKS

You Will Be Able to Say a Thousand Wooo
ooooooooooooooooooooooooooooooooooooooo
ooooooooooooooooooooooooooooooooooooooo
ooooooooooooooooooooooooooooooooooooooo
ooooooooooooooooooooooooooooooooooooooo
ooooooooooooooooooooooooooooooooooooooo
ooooooooooooooooooooooooooooooooooooooo
ooooooooooooooooooooooooooooooooooooooo
ooooooooooooooooooooooooooooooooooooooo
ooooooooooooooooooooooooooooooooooooooo
ooooooooooooooooooooooooooooooooooooooo
ooooooooooooooooooooooooooooooooooooooo
ooooooooooooooooooooooooooooooooooooooo
ooooooooooooooooooooooooooooooooooooooo
ooooooooooooooooooooooooooooooooooooooo
ooooooooooooooooooooooooooooooooooooooo
ooooooooooooooooooooooooooooooooooooooo
ooooooooooooooooooooooooooooooooooooooo
ooooooooooooooooooooooooooooooooooooooo
ooooooooooooooooooooooooooooooooooooooo
ooooooooooooooooooooooooooooooooooooooo
ooooooooooooooooooooooooooooooooooooooo
ooooooooooooooooooooooooooooooooooooooo
ooooooooooooooooooooooooooooooooooooooo
ooooooooooooooooooooooooooooooooooooooo
ooooooooooooooooooooooooooooooooooords

Edited by 826DC, Foreword by Mike Scalise

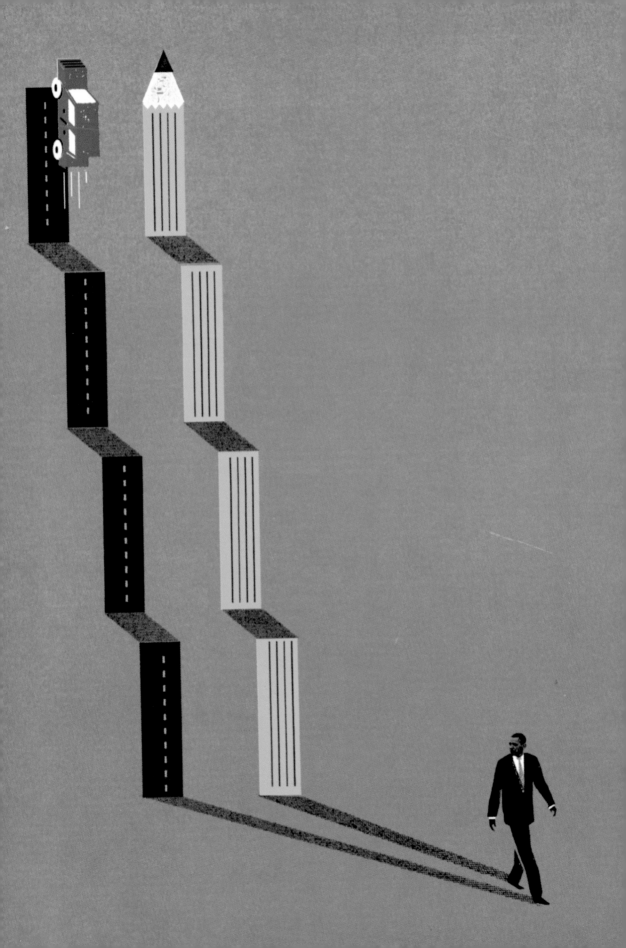

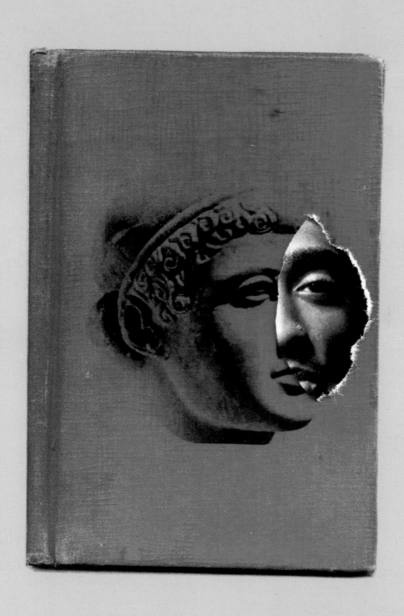

(L) Obama's Legacy
The New York Times, 2012

Teaching the Classics
Columbia Alumni Mag, 2012

Education

115

5.
Environment

| Ornithology and the Environment
The New Yorker, 2015

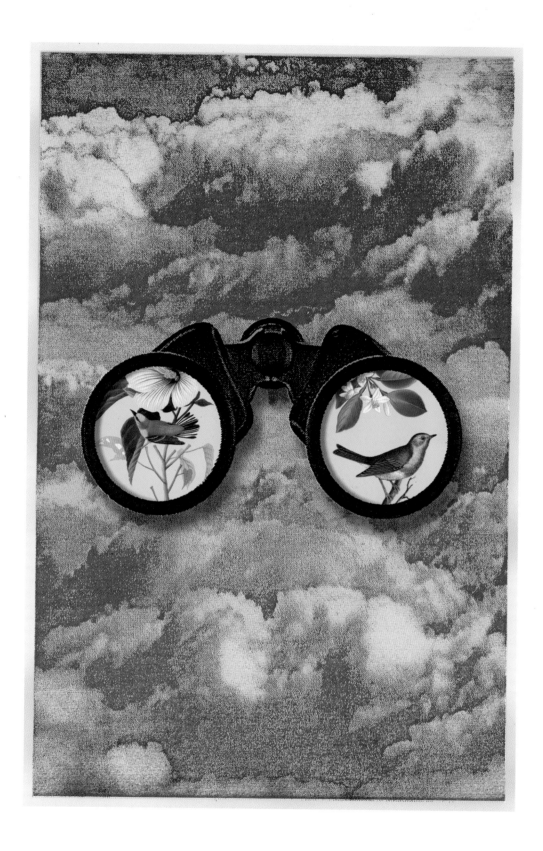

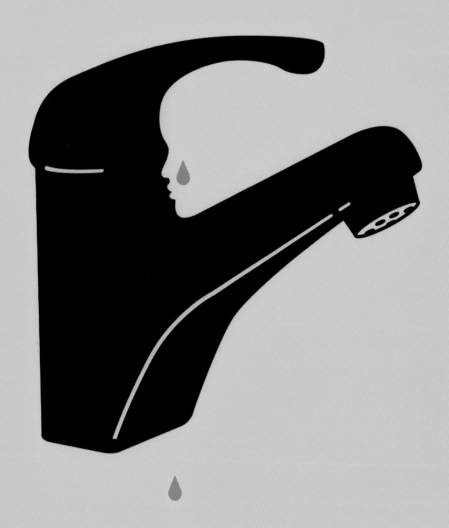

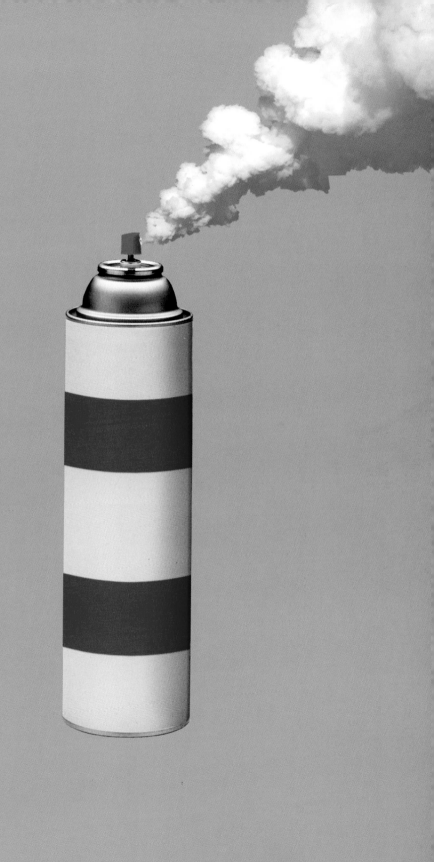

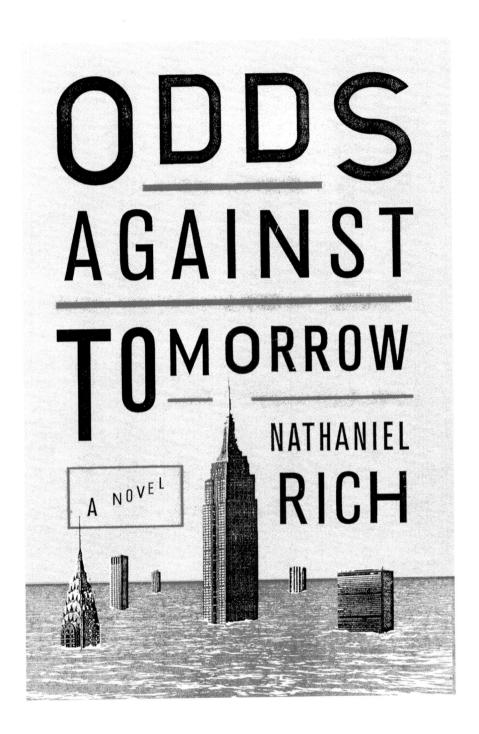

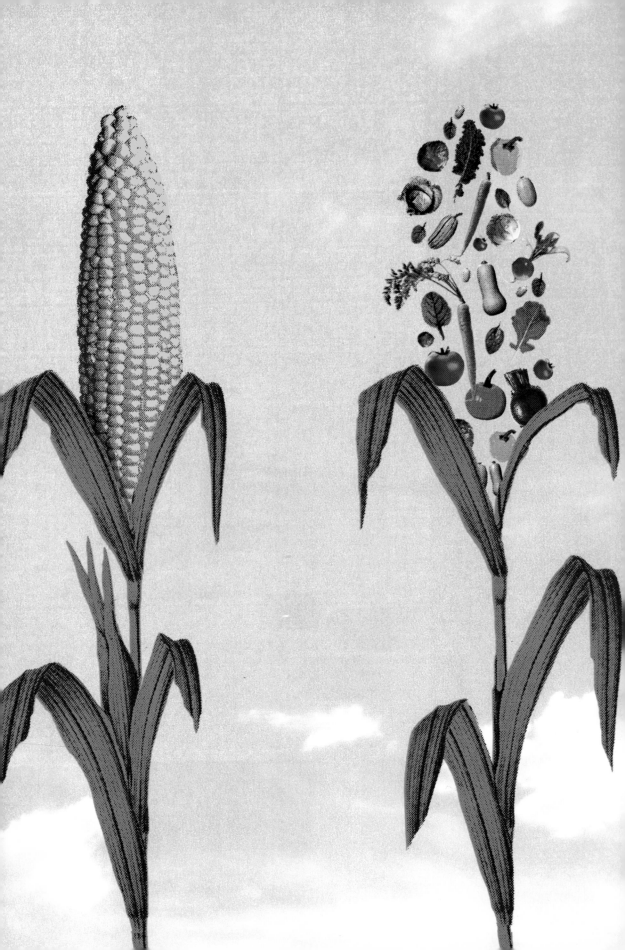

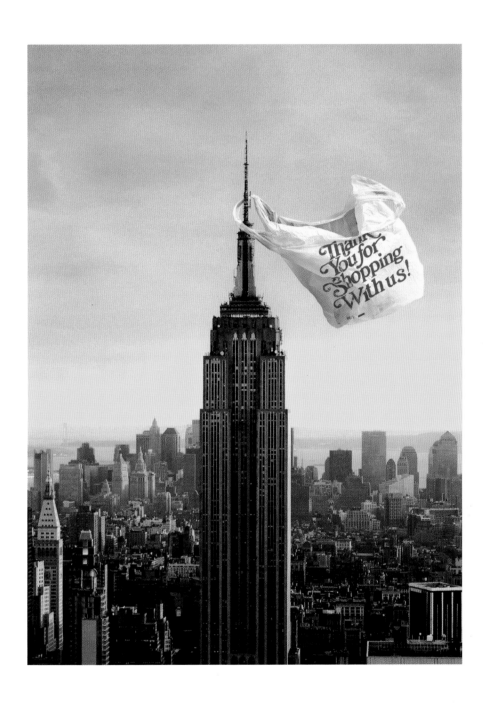

(Previous spread) Tidal Hints
for the Environment
The New York Times, 2016

(L) Protecting
Small Farms
The Washington Post, 2015

The Plastic Bag
Scourge
The New Yorker, 2016

Environment

125

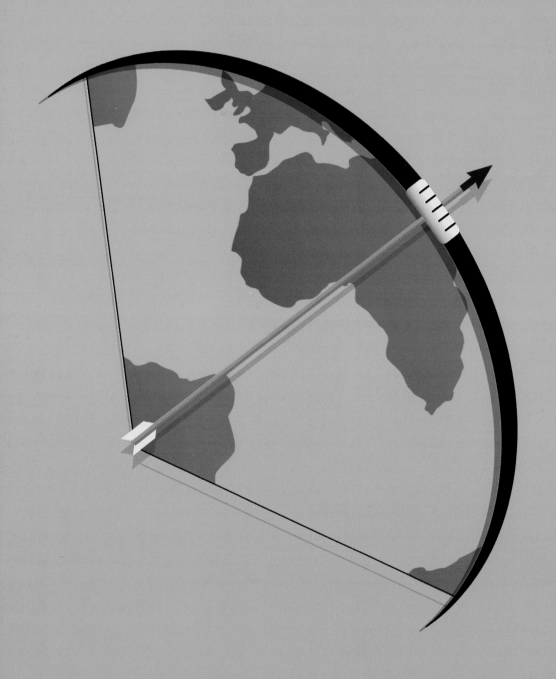

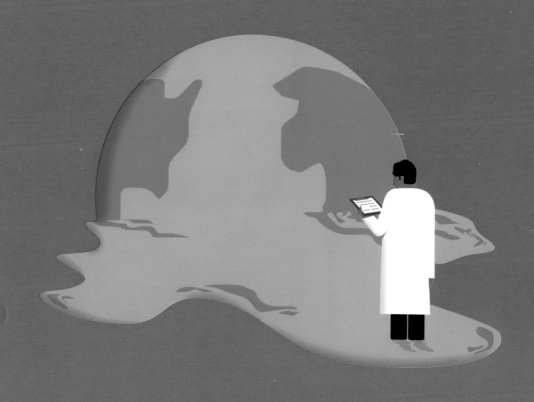

THE

REEF

A
Passionate
History

THE
GREAT
BARRIER REEF
from
CAPTAIN COOK
to CLIMATE
CHANGE

IAIN
M^cCALMAN

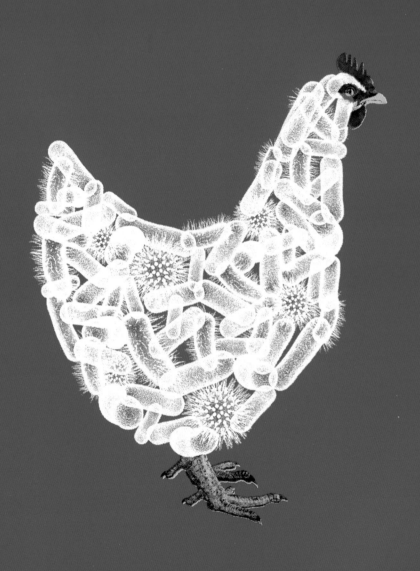

Heritage

An Essay in Images

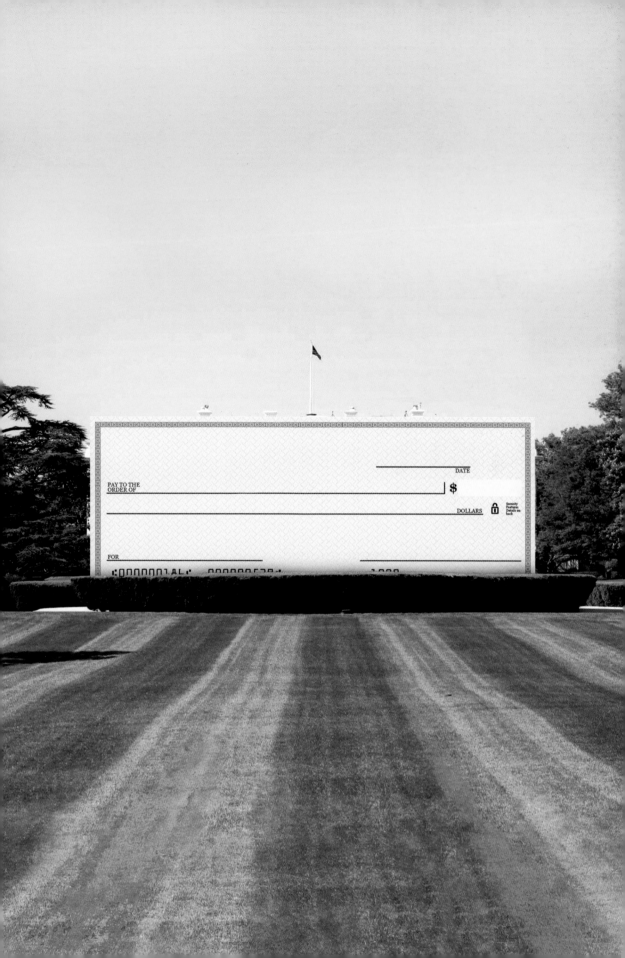

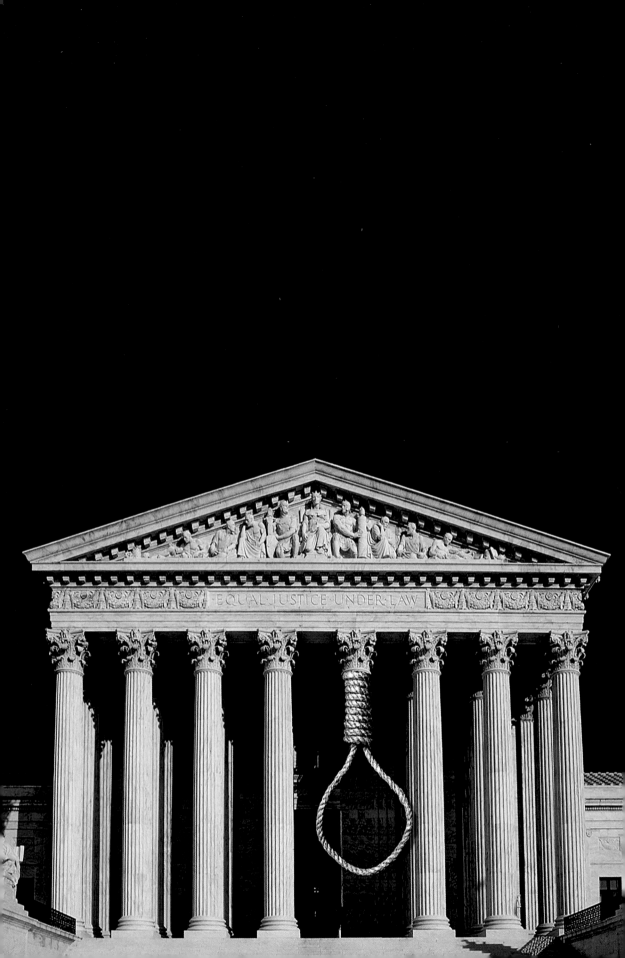

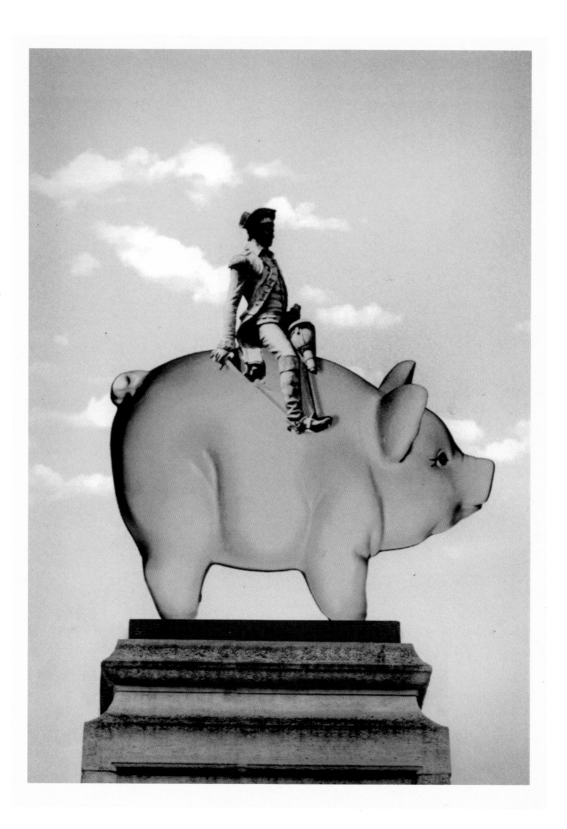

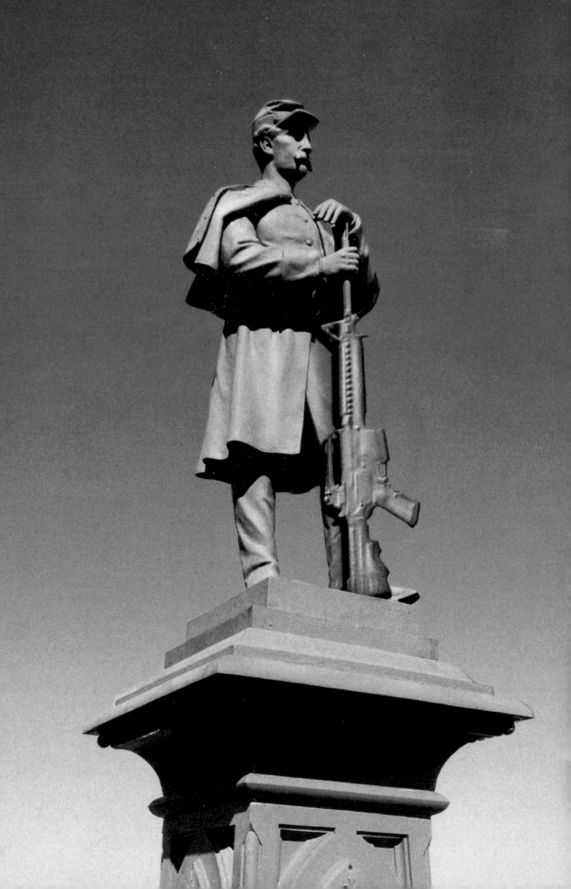

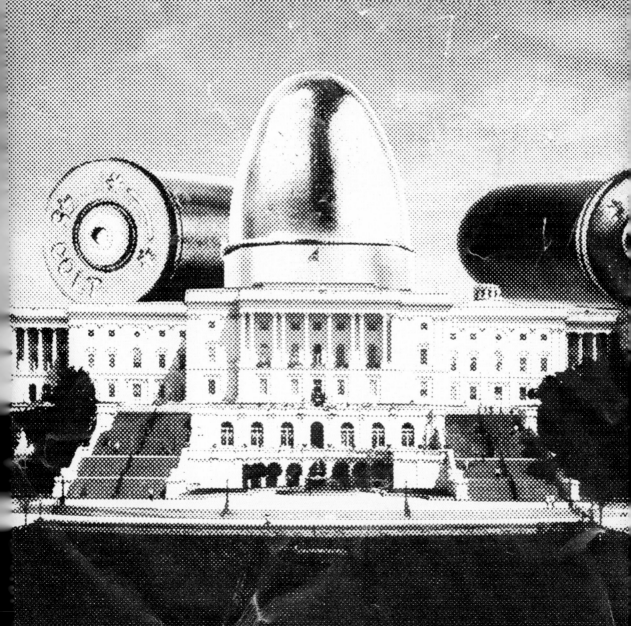

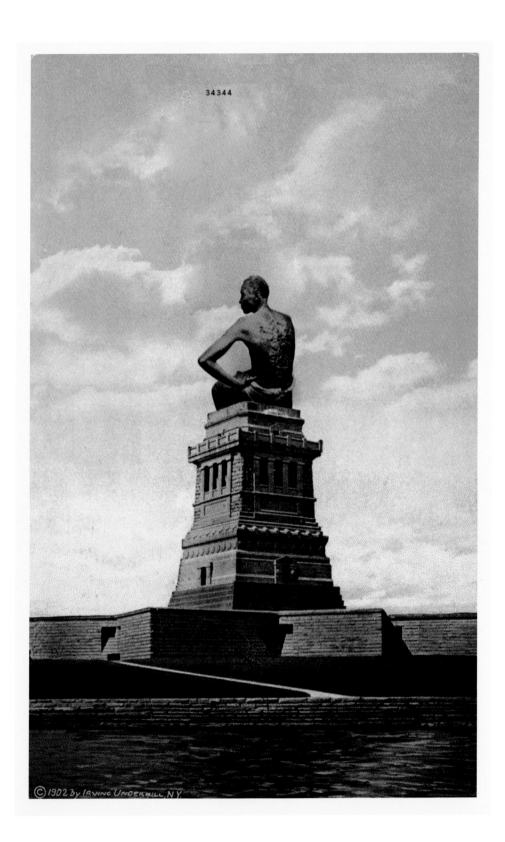

34344

© 1902 by Irving Underhill, N.Y.

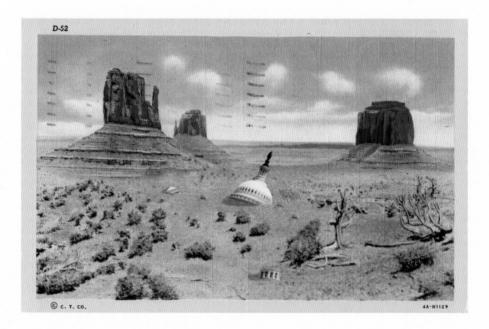

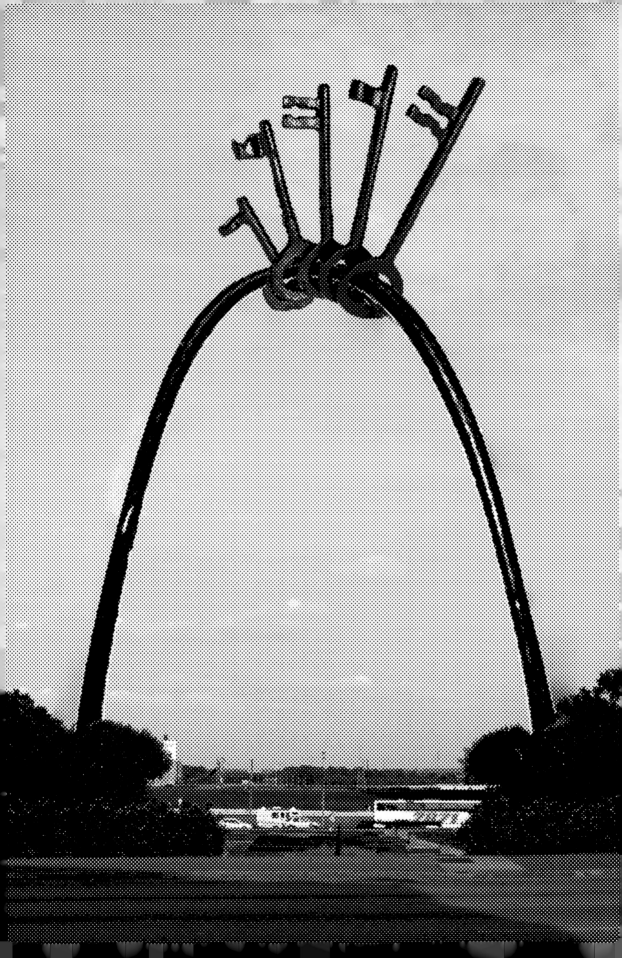

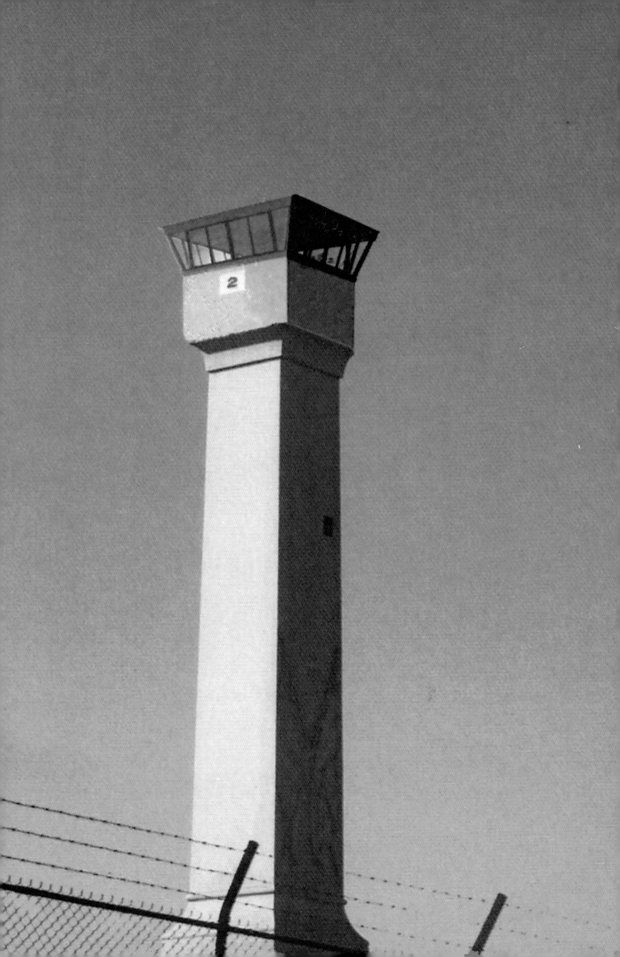

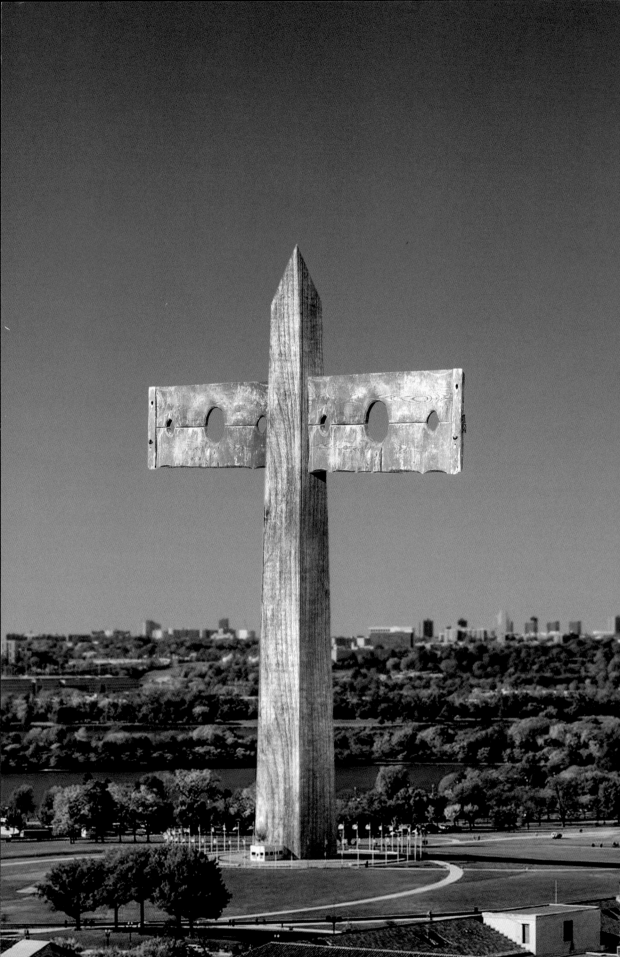

Baltimore Urban Debate League

As students at MICA, we were prevented from entering a nearby Irish bar on certain nights—HBO's The Wire was filming on location. It was something of a rite of passage to watch the show, exciting to recognize the city's landmarks and neighborhoods, occasionally catching a corner of campus in the periphery. The show's genius lay in its depiction of the dynamics playing out on the streets in between, the tension that |so clearly pervaded the city.

It wasn't until the second time I watched the series, years after leaving Baltimore, that an idea struck. Perhaps it was a pining for my former home, or plain old nostalgia, but the epigrams that preceded each episode resonated anew, calling out for a response. Typographic posters seemed like a perfect vehicle.

In a fit of inspiration, I got in touch with Mike Weikert, a former professor from MICA, and discussed the idea, asking if he knew of any community organizations with whom I could partner to sell the prints should the project come to pass. He led me to the Baltimore Urban Debate League (BUDL), a small yet significant organization changing lives for high school students through competitive debate. They'd actually been *in* an episode of the show, and from there it seemed all but inevitable.

The goal was enabling fans to connect with the show and characters they loved—and by extension support its home city—with 100% of the profits going to the organization. I designed the posters in a confluence of styles, bringing together the weighty and iconic Globe Poster— a Baltimore institution—with the expressive iconoclasm of the Russian avant-garde that I loved. After the launch, we held an exhibition of the posters in a gallery on North Avenue, with a live debate about the lasting effects of The Wire on the city's reputation. I still have the honorary BUDL medal in my office.

It turns out that the show's enthusiasts live the world over, but it was an ultra-local supporter who was most surprising. A young actress from the show, still living in Baltimore, ordered a print from the episode that she considered to be her best performance.

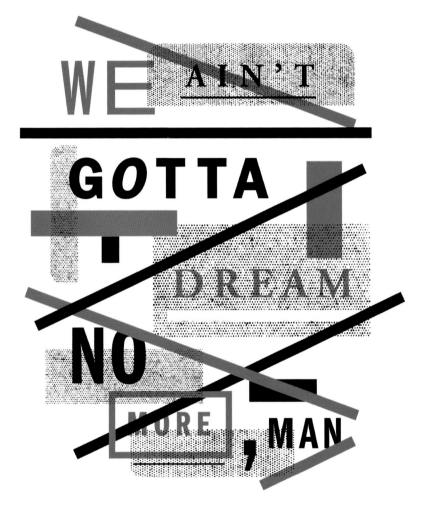

SE 03

WE AIN'T GOTTA DREAM NO MORE, MAN

—STRINGER BELL

EP 11

145

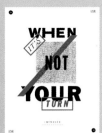
WHEN IT'S NOT YOUR TURN
— McNULTY

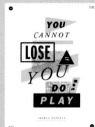
YOU CANNOT LOSE A YOU DO PLAY
— MARLA DANIELS

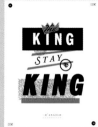
THE KING STAY IS KING
— D'ANGELO

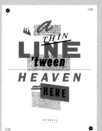
IT'S A THIN LINE 'tween HEAVEN and HERE
— BUBBLES

... a LITTLE SLOW A LITTLE LATE
— AVON BARKSDALE

... AND ALL The PIECES MATTER
— FREAMON

A MAN MUST HAVE a CODE
— BUNK

COME at the KING, YOU BEST Not MISS
— OMAR

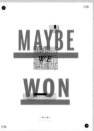
MAYBE WE WON
— MARL

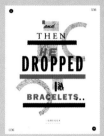
and THEN HE DROPPED IS BRACELETS..
— GREGGS

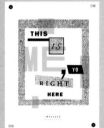
THIS IS ME, YO RIGHT HERE
— WALLACE

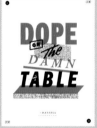
DOPE ON The DAMN TABLE
— DANIELS

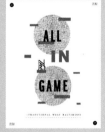
ALL IN THE GAME
— TRADITIONAL WEST BALTIMORE

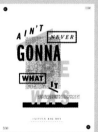
AIN'T NEVER GONNA WHAT IT WAS
— LITTLE BIG ROY

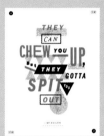
THEY CAN CHEW YOU UP, THEY GOTTA SPIT OUT
— McNULTY

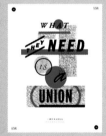
WHAT THEY NEED IS a UNION
— RUSSELL

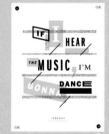
IF I HEAR THE MUSIC I'M GONN DANCE
— GREGGS

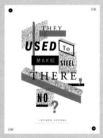
THEY USED TO MAKE STEEL THERE NO ?
— SPIROS VONDAS

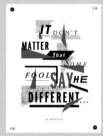
IT DON'T MATTER That SOME FOOL SAY HE DIFFERENT...
— D'ANGELO

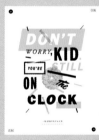
DON'T WORRY, KID YOU'RE STILL ON THE CLOCK
— HORSEFACE

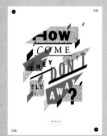
HOW COME THEY DON'T FLY AWAY ?
— ZIGGY

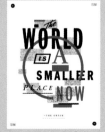
The WORLD IS A SMALLER PLACE NOW
— THE GREEK

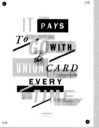
IT PAYS To GO with the UNION CARD EVERY TIME
— ZIGGY

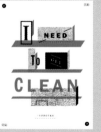
I NEED To GET CLEAN
— SOBOTKA

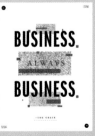
BUSINESS. ALWAYS BUSINESS.
— THE GREEK

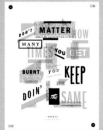
DON'T MATTER HOW MANY TIMES YOU GET BURNT YOU KEEP DOIN' THE SAME
— BODIE

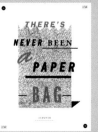
THERE'S NEVER BEEN a PAPER BAG
— COLVIN

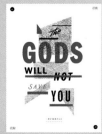
The GODS WILL NOT SAVE YOU
— RUSSELL

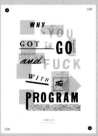
WHY YOU GOT To GO and FUCK WITH The PROGRAM
— PROP JOE

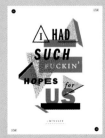
I HAD SUCH FUCKIN' HOPES for US
— McNULTY

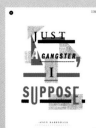
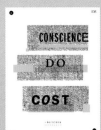
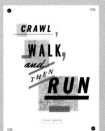
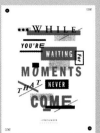
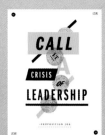
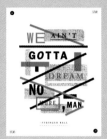
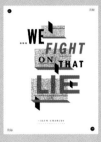
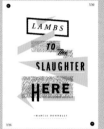
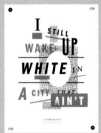
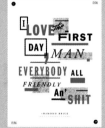
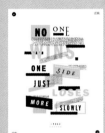
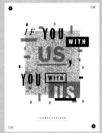
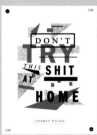
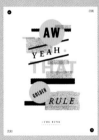
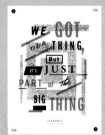
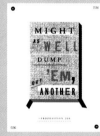
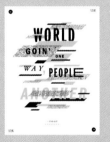
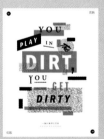
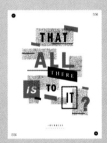
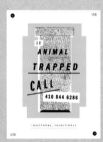
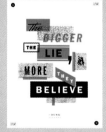
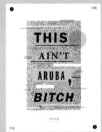
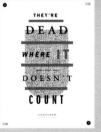
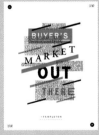
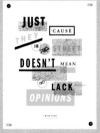
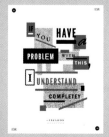

6.
History

An Unexpected Alliance with Ho Chi Minh
The New York Times, 2014

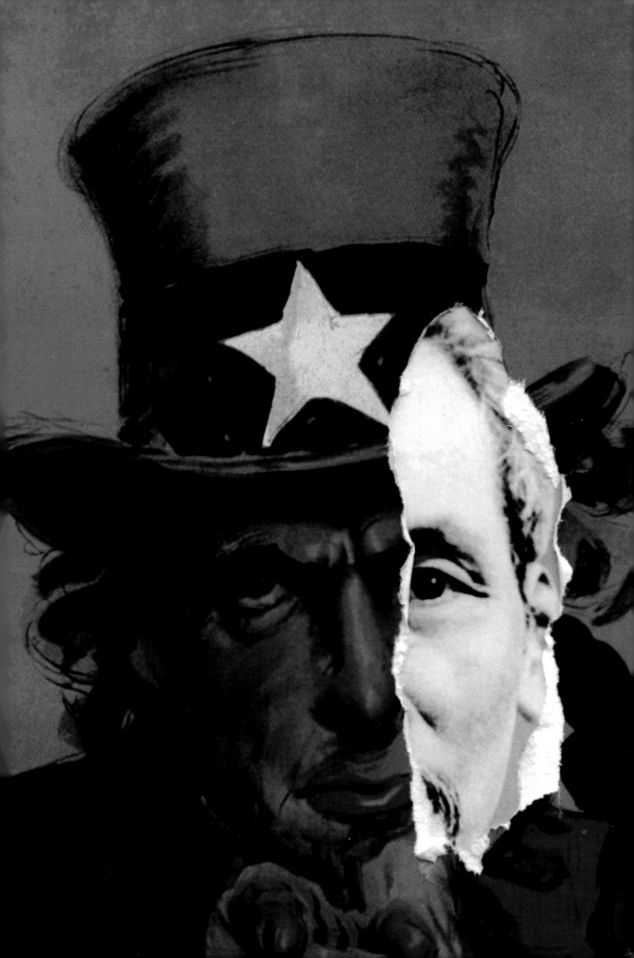

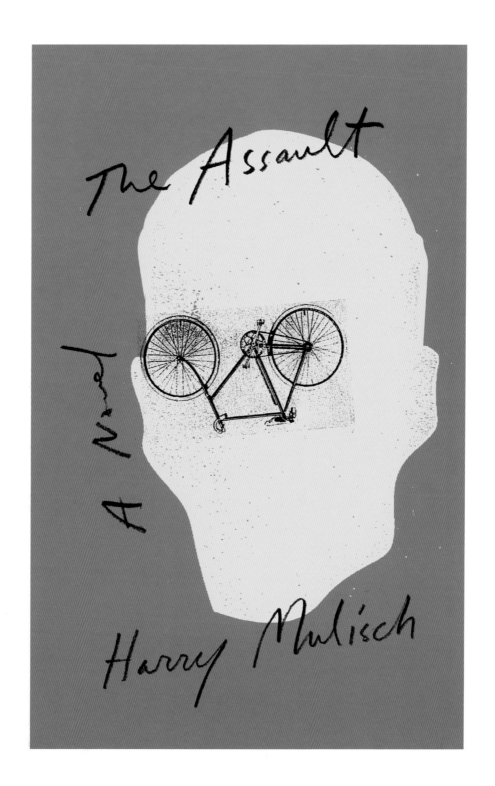

THE LEOPARD *a novel*

GIUSEPPE DI LAMPEDUSA

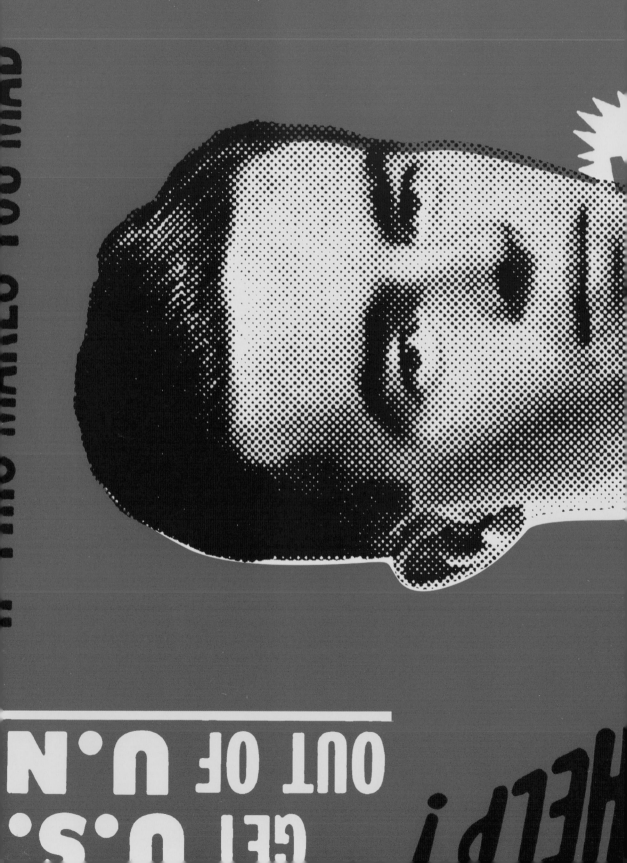

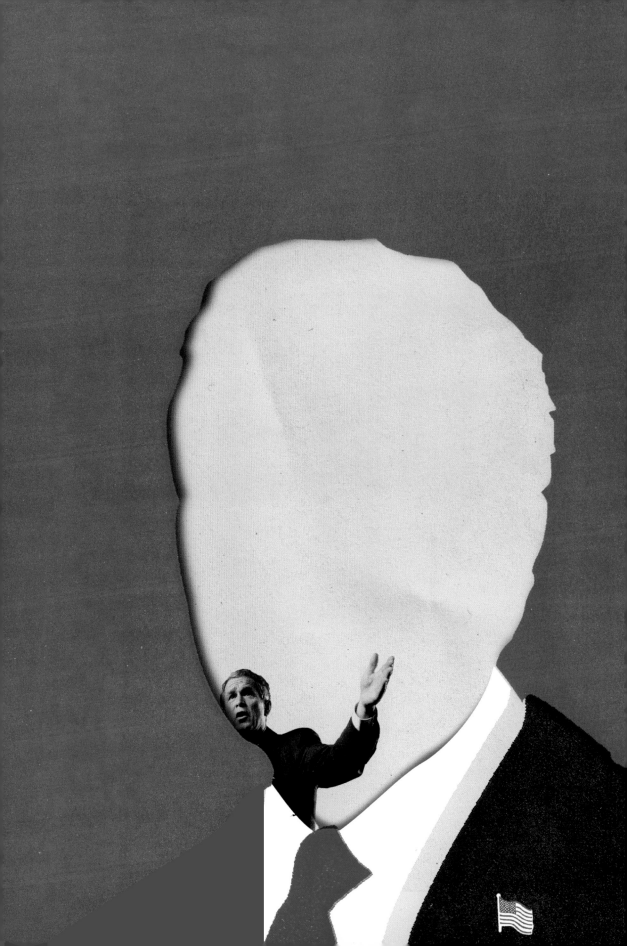

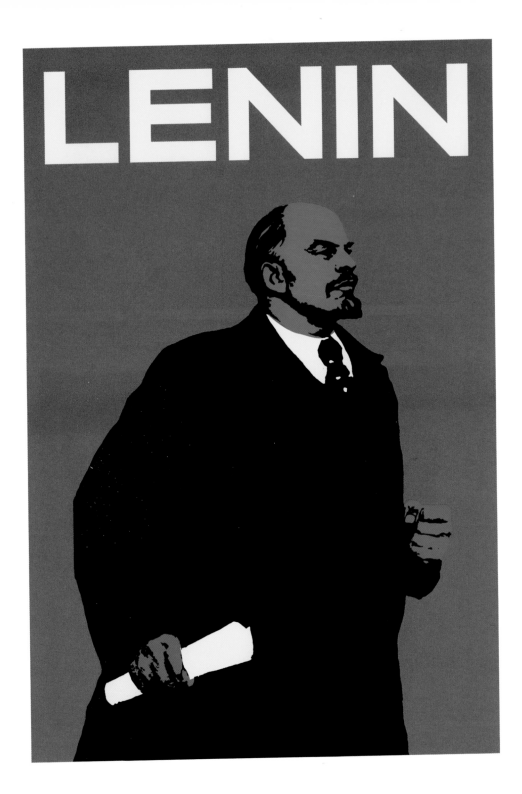

(Previous spread)
(L) A History of the John Birch Society
The New Yorker, 2016

(R) G.W.B., an Appraisal
The New Yorker, 2016

THE HOUSE

of the DEAD

SIBERIAN EXILE

UNDER *the* TSARS

DANIEL BEER

(L) Book jacket Book jacket
Pantheon, 2018 Knopf, 2017

19

46

THE MAKING OF THE MODERN WORLD

VICTOR
SEBESTYEN

The New York Times

Book Review

January 30, 2011

Copyright © 2011 The New York Times

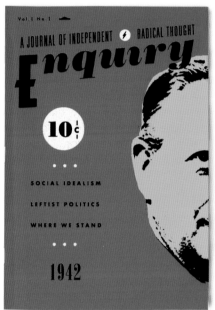

ILLUSTRATION BY OLIVER MUNDAY

Brute
Reason

By Paul Berman

THE NEOCONSERVATIVE PERSUASION Selected Essays, 1942-2009. *By Irving Kristol.*
Edited by Gertrude Himmelfarb. Foreword by William Kristol. 390 pp. Basic Books. $29.95.

Irving Kristol, who died in 2009, is sometimes called the "godfather" or even "father" of neoconservatism, and the patriarchal honorific, like a well-worn hat, sits comfortably atop "The Neoconservative Persuasion: Selected Essays, 1942-2009." The book is strictly a family enterprise. It has been lovingly edited by Kristol's widow, the historian Gertrude Himmelfarb, and carries a prefatory funeral eulogy by their sorrowful son, the Republican journalist William Kristol. Even the selection

Continued on Page 10

STEPHEN BURN: **JOSEPH McELROY'S** 'NIGHT SOUL' PAGE 9 | JUDITH SHULEVITZ: **H. G. ADLER'S** 'PANORAMA' PAGE 16

(L) Book jacket
Pantheon, 2015

Cover
*The New York Times Book
Review,* 2011

History

157

ALEKSANDR SOLZHENITSYN

TRANSLATED BY H.T. WILLETTS

WINNER OF THE NOBEL PRIZE IN LITERATURE

NOVEMBER 1916

A NOVEL

FSG CLASSICS

A LEKSANDR

TRANSLATED BY H.T. WILLETTS

S OLZHENITSYN

FSG CLASSICS

A UGUST
1914

A NOVEL

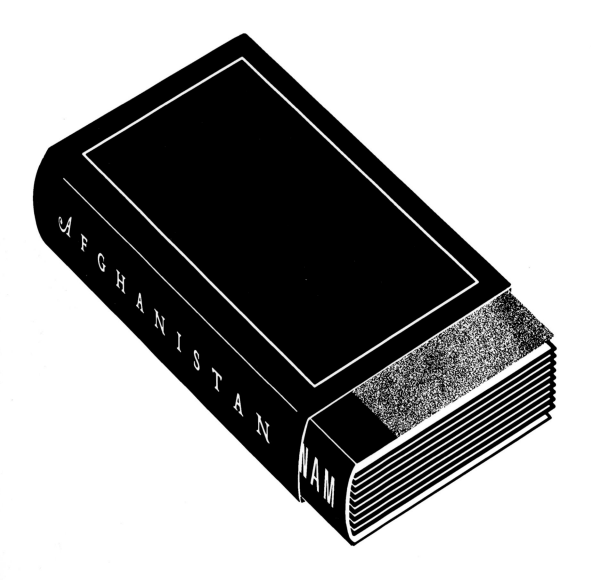

History

(Previous spread)
Book covers
FSG, 2013

Lessons from Vietnam
The New Yorker, 2009

(R) Book jacket
Knopf, 2014

CHINA 1945

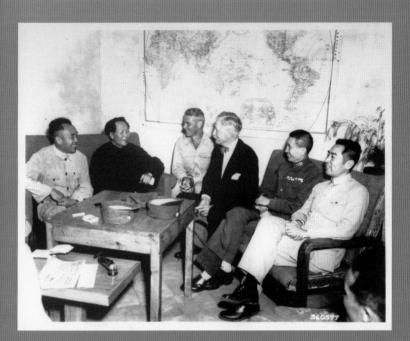

RICHARD BERNSTEIN

MAO'S REVOLUTION AND
AMERICA'S FATEFUL CHOICE

7.
Economy

Cover
TIME, 2011

OCTOBER 3, 2011

The Palestinian
Statehood Debate

Plus: How the
Arab Spring
weakens Iran
BY FAREED ZAKARIA

What the U.S.
should do to fix
its infrastructure

SOUTH KOREA
**Kids, stop
studying
so hard!**

TIME

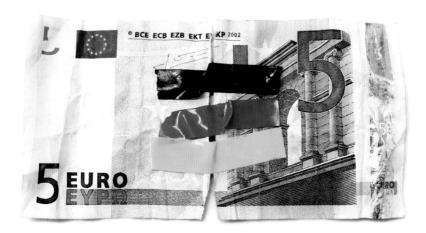

WHY GERMANY CAN'T
SAVE THE WORLD*

BY MICHAEL SCHUMAN

*Not just
because
it doesn't
want to

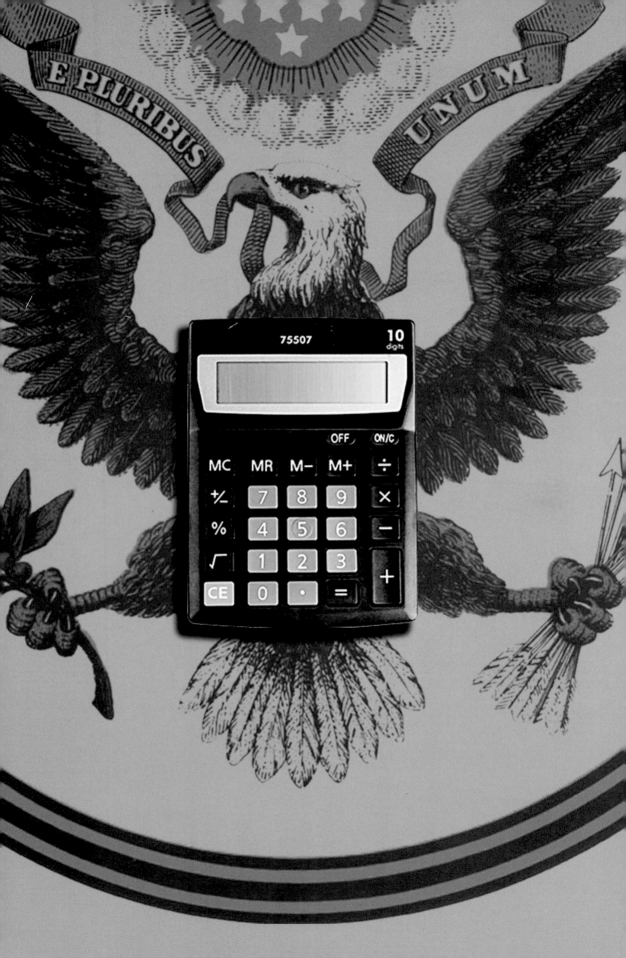

(Previous spread)
(L) Faith in Mint
The New York Times, 2009

(R) Buying the Vote
The New York Times,
2009

(L) Balancing Budgets
The New York Times, 2015

Poster
Complaints!, 2014

167

The Global Rise
of the
Informal Economy

Ur

STEALTH

OF

NATIONS

ROBERT

NEUWIRTH

€

Seven Bad

Ideas

How Mainstream

Economists Have

Damaged America

and the World

Jeff Madrick

Economy | Book jacket
Knopf, 2014 | (R) Born into Privelege
The New Yorker, 2014

 ADD TO CART

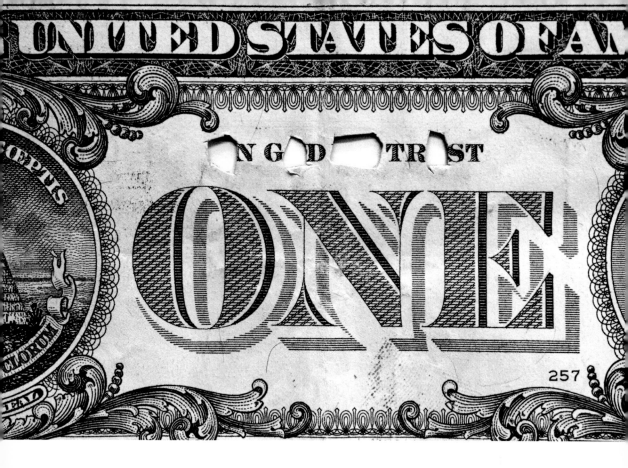

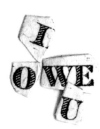

(L) Amazon's Ambition
The New York Times, 2017

Debt Negotiations
The New York Times, 2013

Economy

173

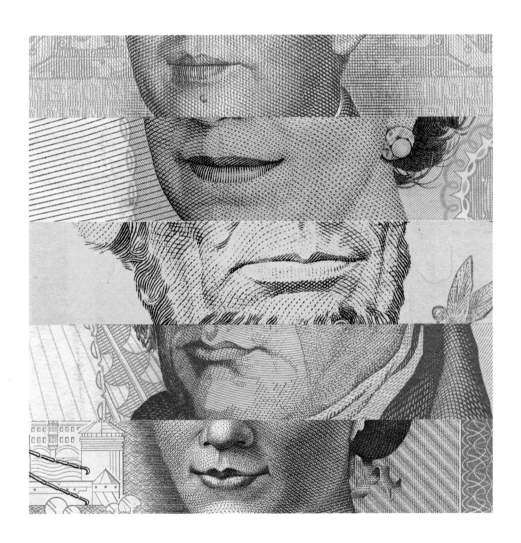

Economy The Language of Money (R) Poster
The New Yorker, 2013 Up, 2010

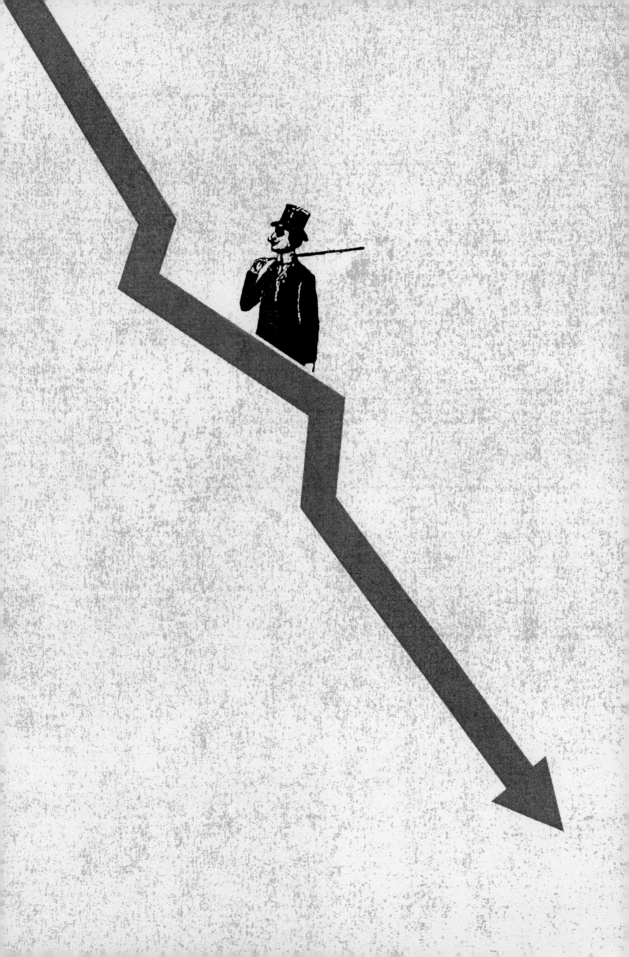

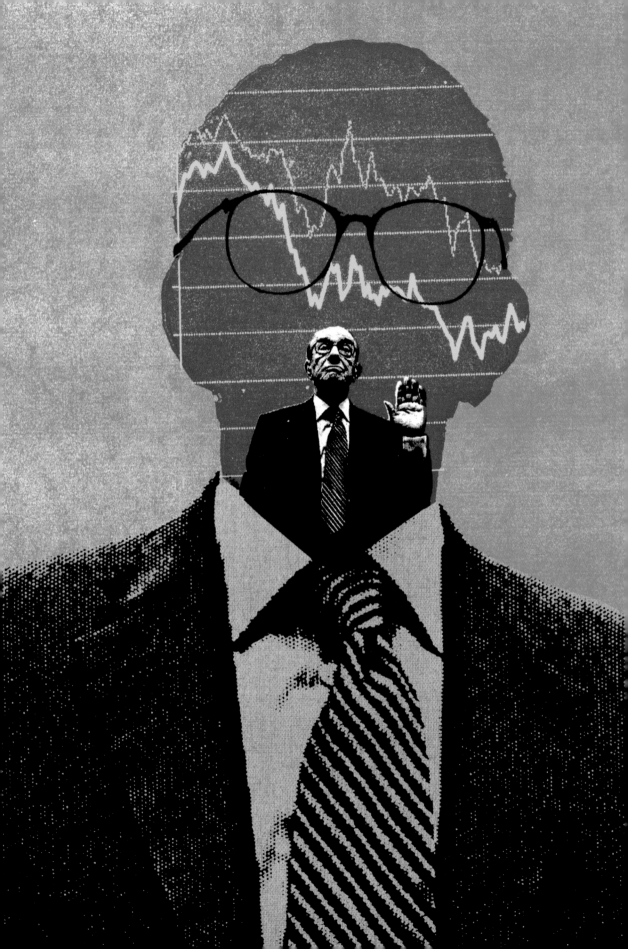

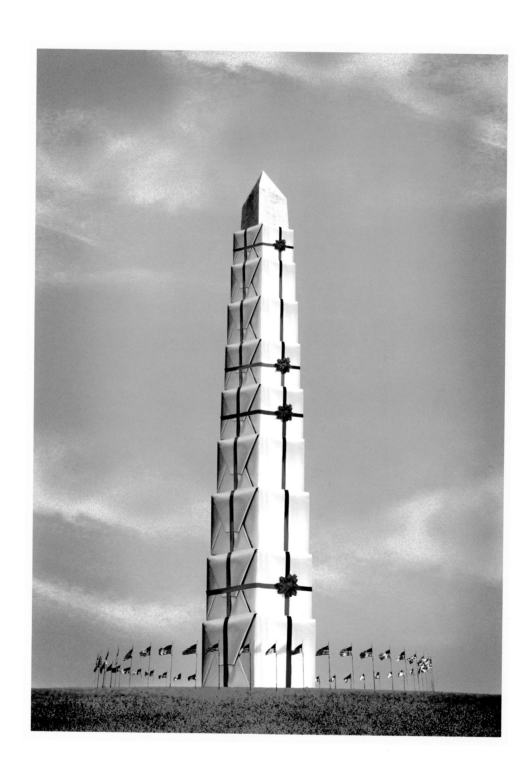

(L) Greenspan
The Washington Post, 2014

Philanthropic Tax Breaks
The New Yorker, 2016

Economy

177

8.

Health

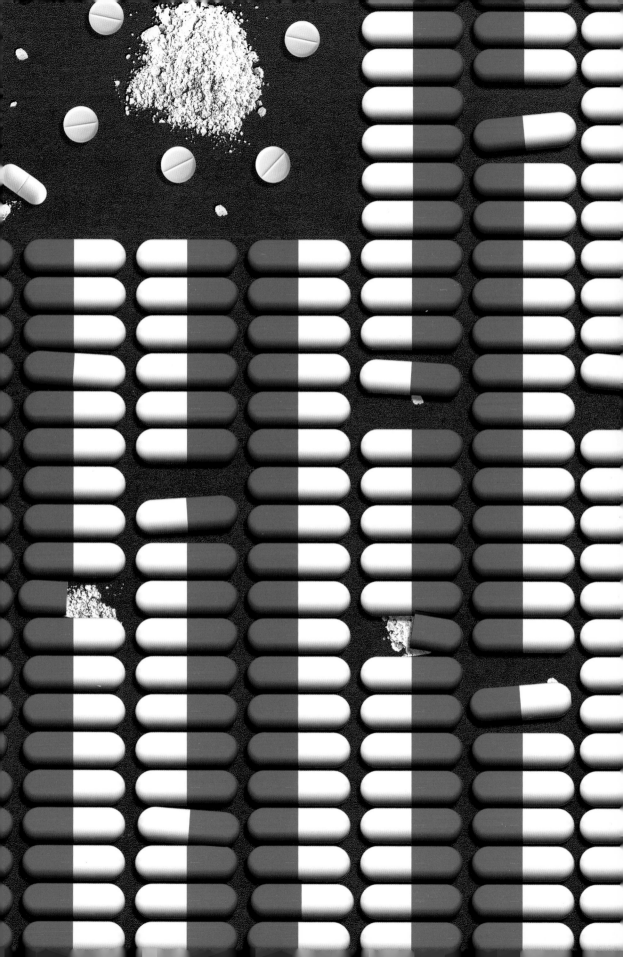

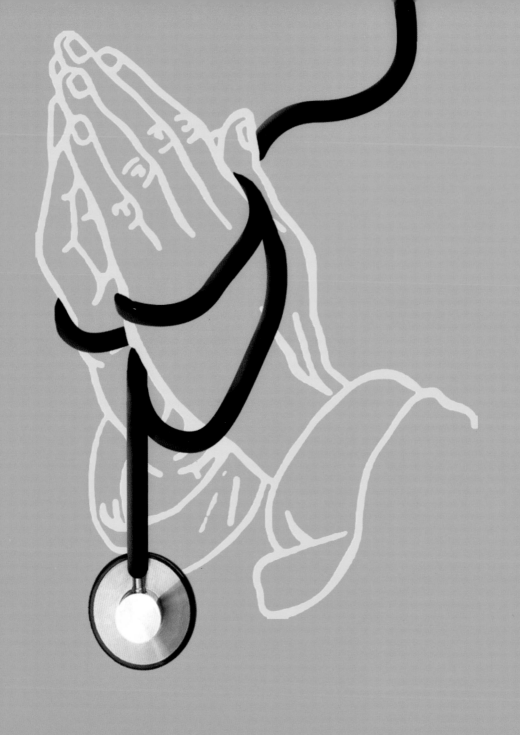

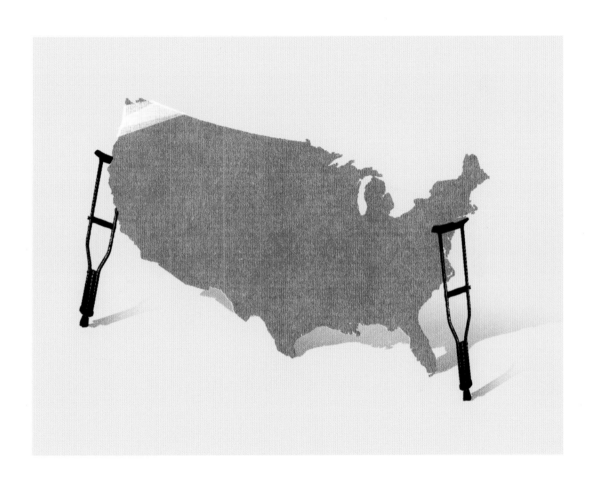

(L) Insuring Evangelicals
BuzzFeed, 2017

National Healthcare Crisis
TIME, 2011

Health

181

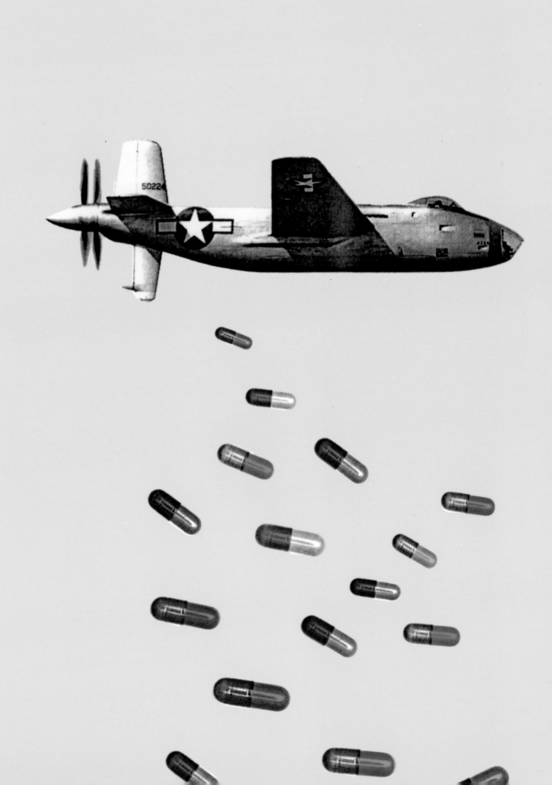

(Previous spread)
(L) An Extremist Threat to Public Health
The New York Times, 2016

(R) Our History of Antibiotics
The New York Times, 2013

START

FINISH

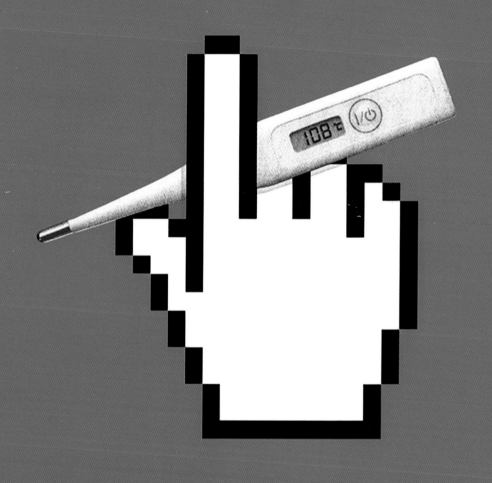

(Previous spread) (R) Tech and Diabetes (L) Safe Sex on Joys of 189
(L) Maladies of the Exchange *WIRED*, 2016 Campus Vegetarianism
TIME, 2013 *Newsweek*, 2015 *Chicago*, 2013

9.
Foreign
Policy

| Congressional Action on ISIS
The New York Times, 2015

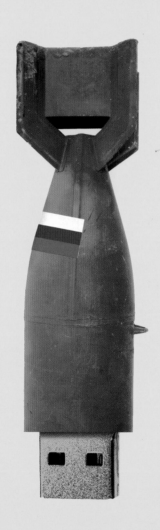

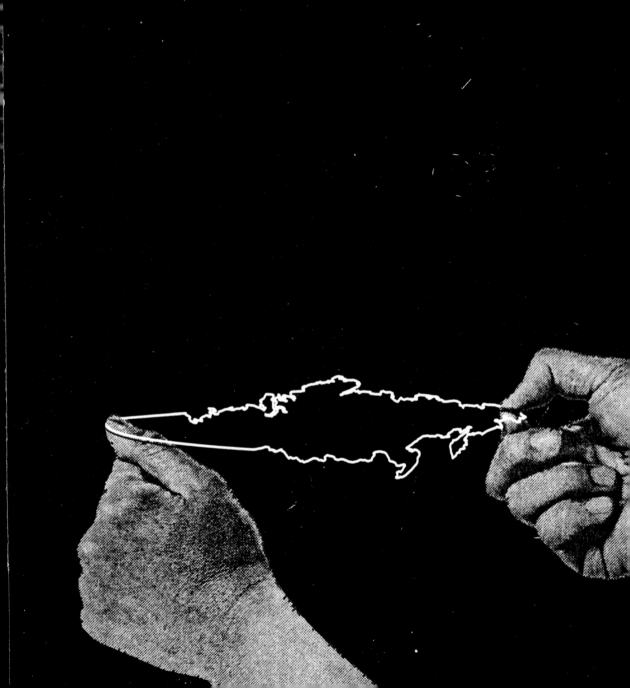

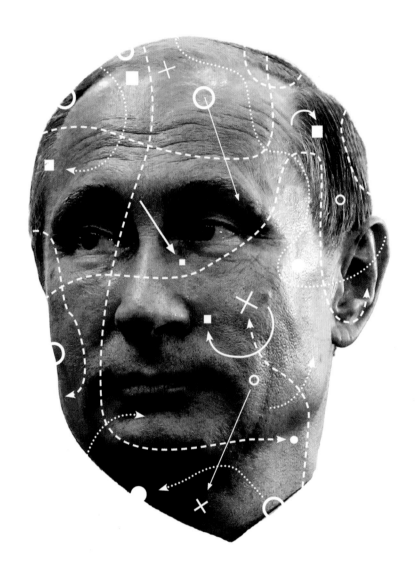

(Previous spread)
(L) Russia's Hacker Army
Newsweek, 2015

(R) Russia's Antagonism
The New York Times, 2017

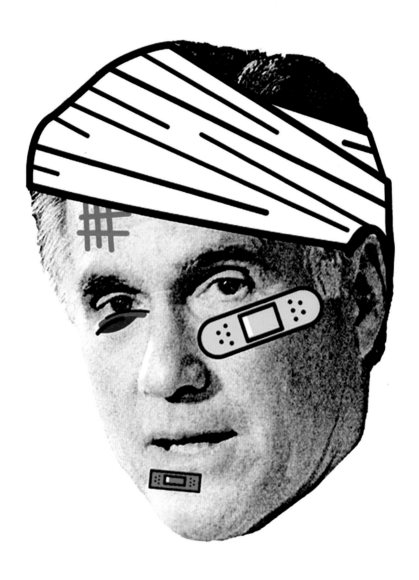

(L) A Plan for Putin
The New York Times, 2015

Mitt's Beating
TIME, 2011

**Foreign
Policy**

195

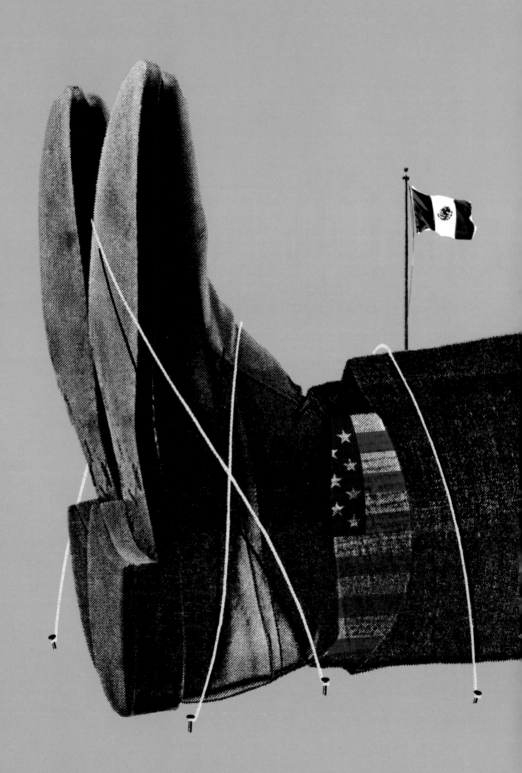

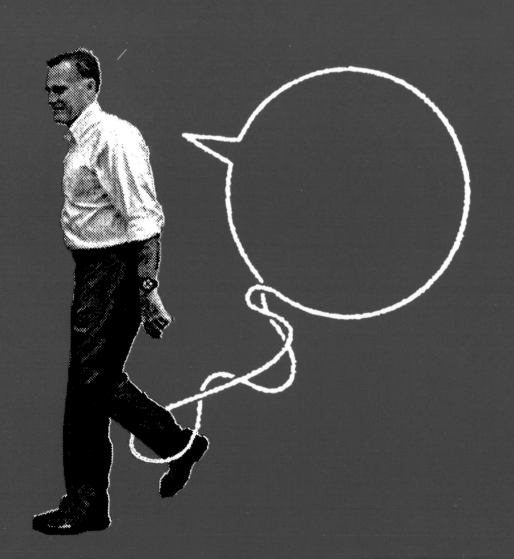

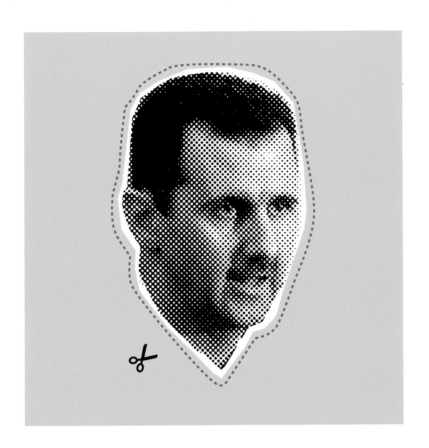

(Previous spread)
A Swiftian Felling
The Atlantic, 2017

(R) Mitt's Gaff
New York Magazine, 2011

(Top) Dealing with Assad
TIME, 2011

Handling Gaddafi
TIME, 2011

199

Cuba Skate

After a semester abroad at *Casa de las Américas* in Havana, Miles Jackson befriended a local community of enthusiastic skaters struggling to make due with threadbare equipment. The communist country posed problems for acquiring gear and hardware. In an effort to help, he brought extra duffel bags filled with skate shoes, trucks, and decks when returning to visit. It was this modest start that eventually led to the founding of Cuba Skate, and Miles has since built skate parks, organized gallery exhibitions, and hosted cultural exchanges with the likes of Georgetown University and Vans.

I've worked with Cuba Skate for the last seven years, and its growth remains incredible to watch. A key to the organization's success is also a truth about skateboarding: it's a cultural conduit. For the youth in Havana and beyond, an interest in skating has the potential to empower, but can also reveal new passions. Cuba Skate is constantly adding areas of interest to its scope: filmmaking, carpentry, even graphic design.

In the early days, before they became an official 501(c)(3) non-profit, I traveled to Cuba with Miles and his team, staying in one of the storied hotels overlooking the Malécon. One evening, I found myself atop a board, rolling with a pack of teenage skaters down Havana's beautifully dilapidated streets. An old feeling rushed back, that ineffable sense of being a part of something greater than myself as the wheels spun beneath me. In the moment, I realized something about Cuba Skate, a rare but important fact that was also true of Miles: youthful passions have a chance of aging well.

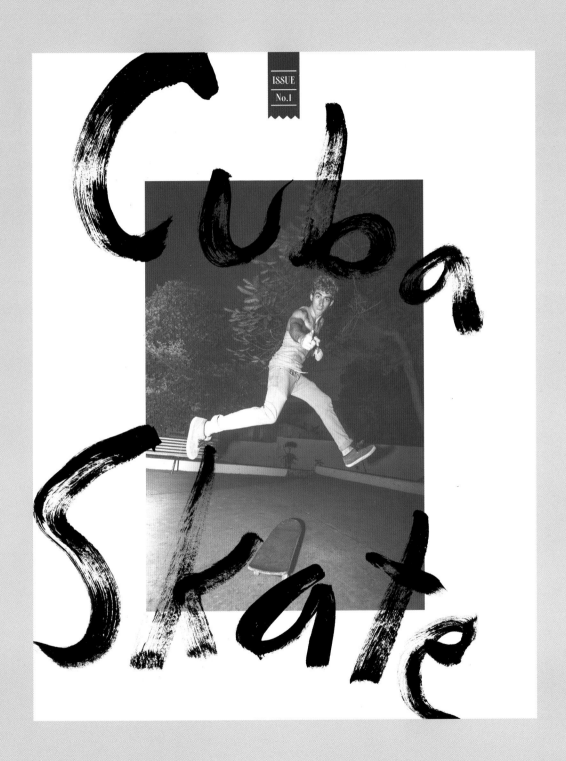

ISSUE No.1

Cuba Skate

¡ PATINETA O MUERTE !

Cuba Skate

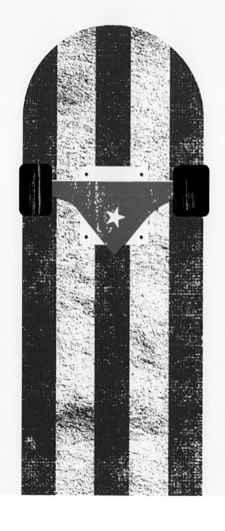

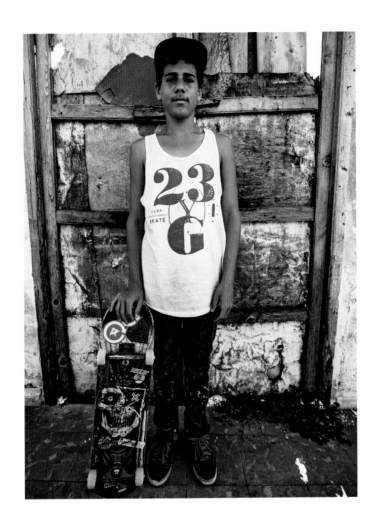

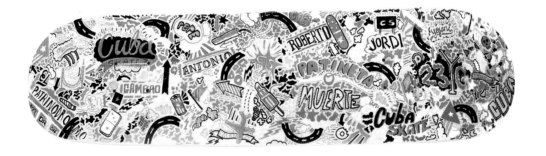

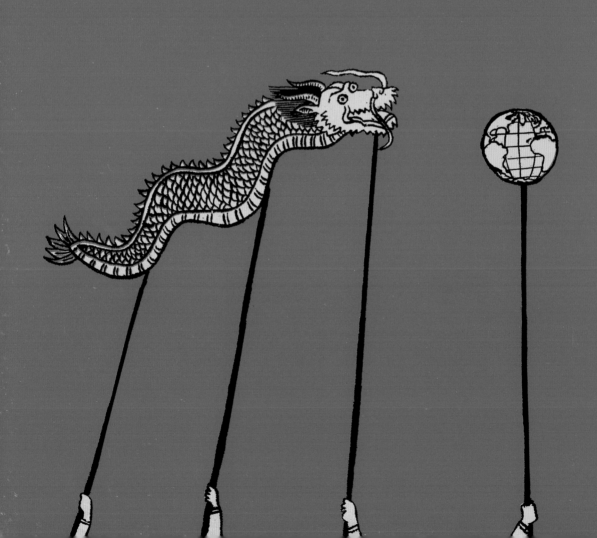

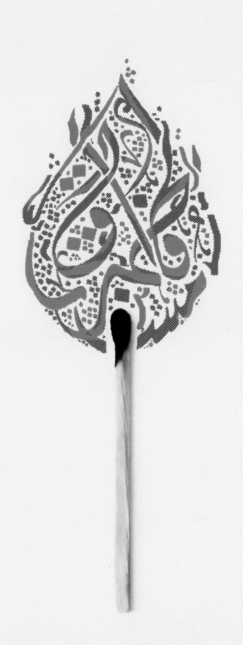

206 | (Previous spread)
(L) China's Looming Threat
The Atlantic, 2016

(R) The Arab Spring
(unused)
TIME, 2010

(L) Iran's Nuclear Program
The New York Times, 2008

Putin's Appeal Against a Syrian Strike
The New York Times, 2008

**Foreign
Policy**

207

The Slot-Machine Trap
How Casinos Create Addicts

The Atlantic

CHINA'S GREAT LEAP BACKWARD

**THE NEXT
THREAT TO
THE GLOBAL
ORDER**

By James Fallows

**HOW TO
AVOID
WAR WITH
BEIJING**

Jeffrey Goldberg
talks with
Henry Kissinger

+

The Case Against Cats

Zadie Smith's Cryptic New Novel

The Godfather of Trolling

DECEMBER 2016
THEATLANTIC.COM

AMERICAN WARLORD

A TRUE STORY

JOHNNY DWYER

Book Review

The New York Times
NOVEMBER 24, 2013

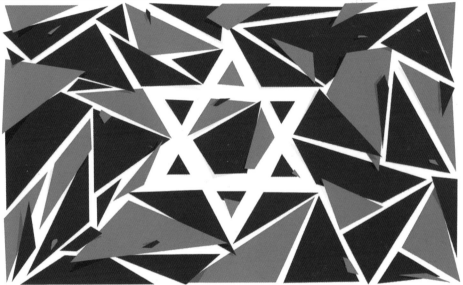

OLIVER MUNDAY

The State of Israel

By Leon Wieseltier

TOO MUCH OF the discourse on Israel is a doubting discourse. I do not mean that it is too critical: Sometimes it is, sometimes it isn't. I mean that the state is too often judged for its viability or its validity, as if some fundamental acceptance of its reality is pending upon the resolution of its many problems with itself and with others. About the severity of those problems there is no question, and some of them broach primary issues of politics and morality; but Israel's problems are too often combined and promoted into a Problem, which has the effect of emptying the Jewish state of its actuality and consigning it to a historical provisionality, a permanent condition of controversy, from which it can be released only by furnishing various justifications and explanations.

In its early years Israel liked to think of itself as an experiment in the realization of various ideals and hopes, but really all societies, including Arab ones, are, in the matter of justice, experiments; and existence itself must never be regarded as an experiment, as if anybody has the authority to declare that the experiment has failed, and

MY PROMISED LAND
The Triumph and
Tragedy of Israel
By Ari Shavit
Illustrated. 445 pp.
Spiegel & Grau. $28.

to try and do something about it. Israel is not a proposition, it is a country. Its facticity is one of the great accomplishments of the Jews' history and one of the great accomplishments of liberalism's and socialism's and nationalism's histories, and it is not complacent or apologetic to say so. The problems are not going away. I cannot say the same about the sense of greatness.

It is one of the achievements of Ari Shavit's important and powerful book to recover the feeling of Israel's facticity and to revel in it, to restore the grandeur of the simple fact in full view of the

CONTINUED ON PAGE 30

(L) Israel's Volatile Policy
The New York Times, 2012

Cover
The New York Times Book Review, 2013

**Foreign
Policy**

211

10.
War

Army Alphabet
Student Project, 2007

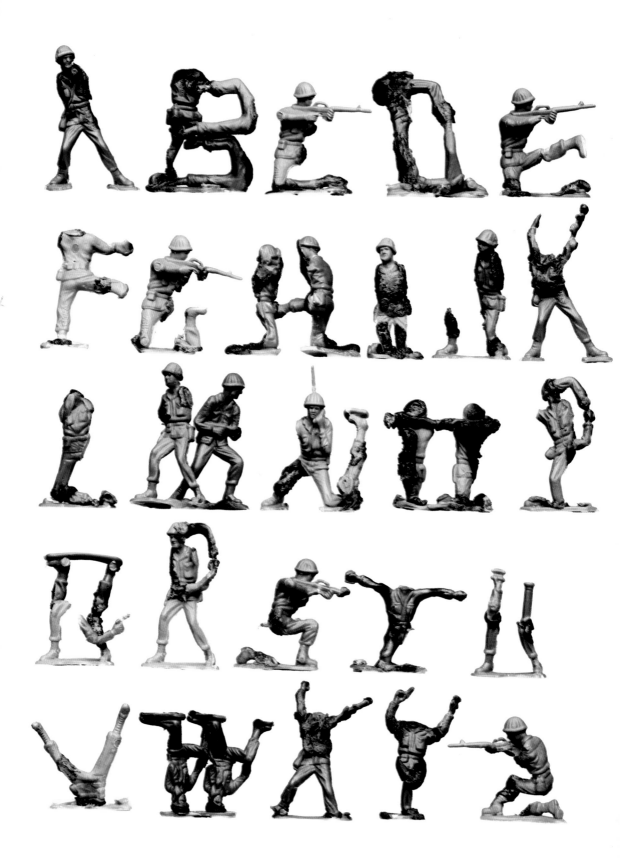

213

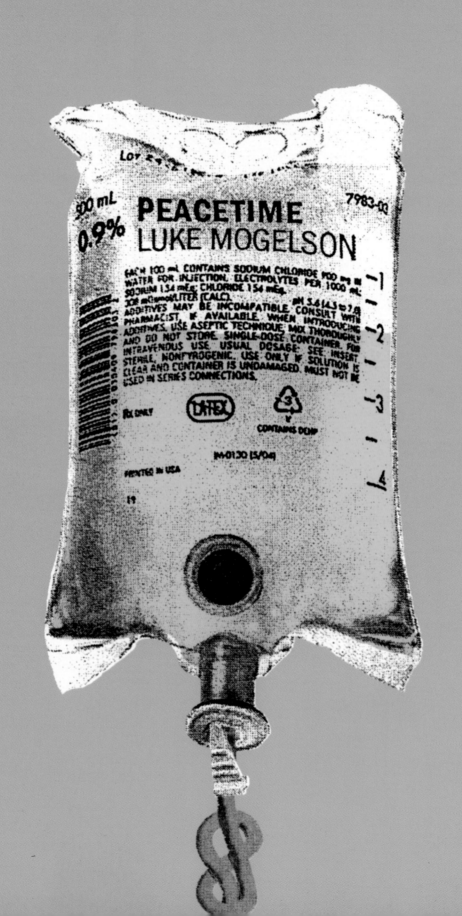

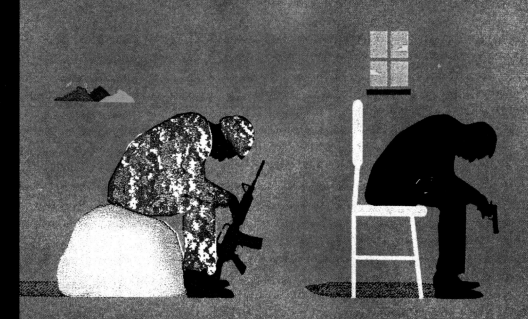
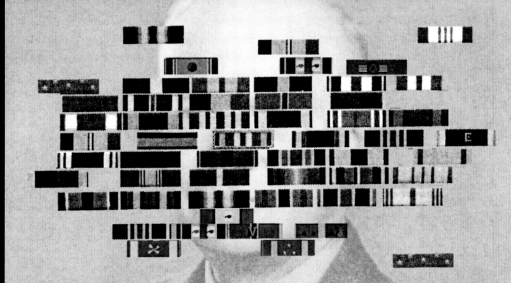

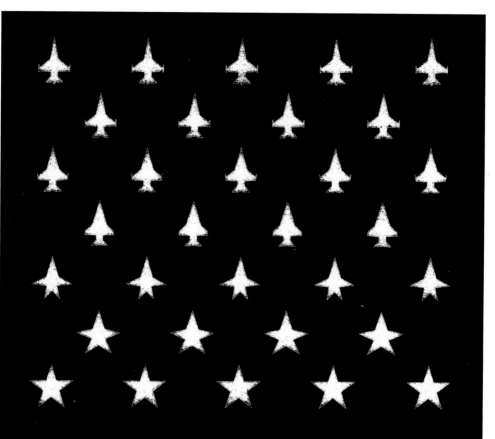

Weapon
of the Strong

Conversations on US State Terrorism

Edited by Jon Bailes and Cihan Aksan

Gilbert Achcar Norman Finkelstein Ismael Hossein-zadeh
Patrick Bond Daniele Ganser Richard Jackson
Judith Butler Greg Grandin Laleh Khalili
Noam Chomsky Edward S. Herman
Richard A. Falk Ted Honderich

Book cover designed with Jason Arias

(Previous spread) (R) PTSD Book cover (R) Cover illustration
(L) Fiction Page *The Washington* Pluto Books, 2011 The Theater of War
The New Yorker, 2015 *Post*, 2014 Knopf, 2015

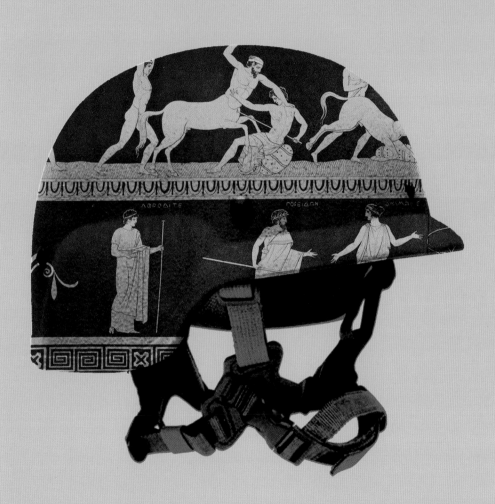

Translated from the Spanish by Anna Kushner

Sabers & Utopias

Visions of Latin America: Essays

Mario Vargas Llosa

Winner of the Nobel Prize in Literature

(L) Book jacket
FSG, 2018

Book jacket
New Directions, 2017

War

219

THE MIRROR TEST

AMERICA AT WAR IN
IRAQ AND AFGHANISTAN

J. KAEL WESTON

MARSHLANDS

MATTHEW OLSHAN

A Novel

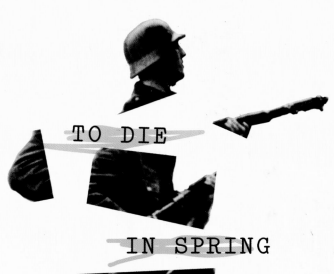

TO DIE

IN SPRING

RALF

ROTHMANN

A NOVEL

Book jackets
FSG, (L) 2013, (R) 2017

Acknowledgments

Mom, Dad, Clare, Grandma, Robin, Lillian, Sam, Gabriel, Seyon, Nick, Dante, Adebayo, David, Lena, Rowan, Giselle, Peter M., Andrew, Jen, Chris, George, Peter T., Mike K., Bernard, Mike W., Ellen, Lew, John B., Steve, and James.

Ian, Meaghan, Charles, and Hilton. Thank you.